MISSING
CROSSING
MIRACLE

Reza de Wet

PLAYS ONE

MISSING
CROSSING
MIRACLE

translations by
the author & Steven Stead

OBERON BOOKS
LONDON

First published in 2000 by Oberon Books Ltd.
(incorporating Absolute Classics)
521 Caledonian Road, London N7 9RH
Tel: 020 7607 3637 / Fax: 020 7607 3629
e-mail: oberon.books@btinternet.com

A catalogue record for this book is available from the British
Library.

ISBN: 1 84002 145 4

Cover illustration: Andrzej Klimowski

Cover typography: Jeff Willis

Printed in Great Britain by Antony Rowe Ltd, Reading.

Contents

Reza de Wet

Reza de Wet is a South African playwright who was born in a small town (Senekal) in the Free State. She has worked extensively as an actress, has a Master's degree in English Literature and currently lectures in the Drama Department of Rhodes University in Grahamstown.

Reza de Wet is a prolific writer who has written eleven plays in fourteen years (four in English and seven in Afrikaans). She has won more major South African theatre and literary awards than any other writer (including Athol Fugard). She has won nine awards for her scripts (five Vita awards, three Fleur du Cap awards and a Dalro award) as well as every prestigious literary award (a CNA prize, a Rapport prize and twice the Herzog prize) and productions of her plays have won more than forty theatre awards. Most recently *Yelena* won the Vita award for the Best Script (1998-1999) while *Drie Susters Twee* was named Best Production for the same year. In *Open Space*, an anthology of new African plays, she is the only woman represented and one of two South African dramatists. Reza de Wet has also achieved the distinction of being the only dramatist to have a play on the official programme at the International Grahamstown festival for three consecutive years. She is also the only playwright (South African or other) to have two of her plays run in tandem at the State Theatre. In a television interview last year (Pasela, October 1999) John Kani claimed he could be lured back to the South African stage only if he was offered a role in one of Reza de Wet's plays.

Her plays are *Diepe Grond*, 1986 (the first play in Afrikaans to be produced by the Market Theatre, Johannesburg, and which has won a record number of theatre awards); *Op Dees Aarde*, 1987, presented by the Performing Arts Council of the Transvaal (PACT) at the Windybrow Theatre in Johannesburg and The Momentum in Pretoria; *Nag, Generaal*, 1988, presented by the Market Theatre Company on the official programme at the Grahamstown Festival and transferred to the Market theatre; *In a Different Light*, 1989, presented by the Market Theatre

Company; *A Worm in the Bud*, 1990, presented by PACT at the Windybrow Theatre in Johannesburg and the Momentum Theatre in Pretoria; *Mirakel*, (Miracle), 1992, opened on the official programme at the Grahamstown Festival and transferred to the Wits Theatre in Johannesburg and the Momentum Theatre in Pretoria; *Mis*, (Missing), 1993, presented by the Cape Performing Board (CAPAB) on the official programme at the Grahamstown Festival and transferred to the Nico Malan Theatre in Cape Town and the State Theatre in Pretoria; *Drif*, (Crossing), 1994, presented by CAPAB, opened on the official programme at the Grahamstown Festival and transferred to the Nico Malan Theatre in Cape Town; *Crossing*, Reza de Wet's English version, 1995, produced by CAPAB, presented at the Nico Malan Theatre in Cape Town; *Drie Susters Twee*, 1997, produced by CAPAB, opened on the official programme at the Karoo Festival and transferred to the Nico Malan Theatre in Cape Town, revived by the State Theatre and performed at the State Theatre in Pretoria; *Yelena*, 1998, presented by the State Theatre, opened on the official programme at the Grahamstown Festival and transferred to the State Theatre in Pretoria. Her latest play is *Brothers*, a biographical play about Anton Chekhov and his brothers.

Author's Note

Productions of *Mis* (Missing), *Drif* (Crossing) and *Mirakel* (Miracle) have been very successful in this country, and although my English version of *Drif* was staged here, I had never felt the need for these plays to 'leave the home'. While I was in London three years ago, I met with ex-South African actor/director Steven Stead who persuaded me that these texts had a wider resonance. A year later he presented me with his fine translations of *Mis* and *Mirakel* which he subsequently showed to distinguished literary agent, Gordon Dickerson, whose encouragement and faith in my work has led to this publication.

Although all three plays share a rural Afrikaans setting, I have attempted to create a self-enclosed world for each play, a world which remains consistent to its own peculiar logic. In this way I wished to lend fantastical situations the quality of irrefutable truth. In this sense I do not feel that these texts need to be understood only in the context of the Afrikaner experience. In fact, the thematic link between the plays (which otherwise function independently) could be seen as a desire to escape the oppressive confines of a too narrowly defined reality in order to enter a more fluid, magical realm. This intimation of a more alluring world underlying the everyday monotony that most of these characters are condemned to; the presence of the extraordinary in the midst of the ordinary, is a particular concern of mine and finds expression in both my Afrikaans and my English writing. As such the texts are personal explorations and not an attempt to portray a particular society. For this reason, I feel that the plays are well equipped to travel to new places and I believe that they will arrive at their new destinations with their frail accoutrements in tact.

Reza de Wet,
Grahamstown
South Africa
2000

MISSING

translated by Steven Stead

Characters

MIEM

A fat, middle-aged woman with a plait
fastened over the top of her head.

MEISIE

A pale young girl with long hair.

GERTIE

A small, middle-aged woman with thin,
mousy hair caught up in a tight bun.

CONSTABLE

A charming, somewhat enigmatic
man aged between thirty and forty.

Setting: the action takes place in a shabby little house on a smallholding on the outskirts of a *platteland* town in central South Africa. There is a back door (right) which opens inwards, with a screen door that opens outwards. A window right of centre and a passage door down front left. A coal stove stands at the back of the stage, left of centre. There is an enamel coffee kettle on the stove. In front of the stove is a small bench, and beneath the window there is a washstand on which an oil lamp burns. Under the washstand are a pitcher and ewer, floor-rags and a bucket. To the left of the back door, against the back wall is a *riempiesbank* (a wood and leather-weave bench).

In the centre, slightly to the left, there is a table covered with an oilskin cloth, and surrounded by four chairs. An oil lamp hangs just above the table, and a roll of hessian or sacking lies on the table. There is a kitchen cupboard or dresser in the back left corner in which pots, pans, crockery, etc are stored. A heap of sacking cut into rectangular strips lies in a pile down front right. On each piece, the words MANURE/MIS are clearly printed in large, black letters. A section of the ceiling can be seen, in which there is a trap door. The floor is covered in a much-worn linoleum, its pattern of red roses and green leaves still vaguely discernible. The walls of the room are made out of corrugated iron, the lower half of which is painted a dull green and the upper half a dirty pink. Faded, floral curtains hang in front of the window, and on a hook on the back door hangs a man's weather-beaten hat.

Time: eight o'clock on the last night of August 1936.

Style: the sets and costumes should convey a sense of the folkloric, of rough fairytale. Similarly, the circus music referred to in the text should be slightly unrealistic; suggested by the slightly mechanical, strangely magical sound of a barrel organ.

Effects: the circus music is very important and can be heard whenever the back door is opened. There must also be a distinct difference between the 'soft, moaning wind' and the gale indicated in the text. The distant barking of police dogs is also occasionally audible.

As the play begins, loud circus music is heard. The music fades. Lights fade up on stage. MIEM and MEISIE are seated at the table. Each is occupied with sewing two pieces of hessian together to make sacks. The trap door falls open noisily. Silence. MIEM and MEISIE carry on working.

MIEM: Count them.

MEISIE: (*She crouches next to the heap of sacks and counts.*)
...Six...ten...seventeen...twenty...twenty-four... twenty-seven.

MIEM: We must have thirty by tomorrow morning. (*Sighs, lifts her leg and rests it on a chair.*)

MEISIE: Yes, Ma.
(*They work on in silence.*)
Eina! (*She sucks her finger.*)

MIEM: Well, if you don't use a thimble, what do you expect, my girl?
(*MEISIE bends her head down and goes on working. As the two women sew, a rope descends from the trap door to about a metre off the floor.*)
(*Seeing the rope immediately.*) The basket's on the table.
(*MEISIE gets up slightly reluctantly, and quickly ties the basket to the rope.*)
Don't be in such a hurry. Tie it properly.

MEISIE: (*Whispering.*) I'm scared...if I look up I might see his bony, old, white hand.

MIEM: (*Softly, but angrily.*) Shame on you! Your own father!
(*She stands with some difficulty and ties the rope tightly to the basket.*) Go ahead. Pull it up.
(*The basket ascends. MEISIE sits down again and resumes work, looking perplexed.*)
(*Looking up and speaking loudly.*) No, hang on a minute. Let it back down again. (*The rope descends again.*)
(*Moving to the table.*) I baked you half a loaf. (*She puts the bread into the basket, and looks up.*) There you go. You can pull it up!
(*She sits back down and resumes her work as the basket ascends.*)

15

(*She looks up. Loudly.*) Oh, yes! Remember the bucket! It's been two days already! (*Softly, to MEISIE.*) He was so restless this afternoon, you know. (*She places her foot on a chair again.*)

MEISIE: (*Nodding.*) I heard.

(*A soft, moaning wind can be heard.*)

MIEM: (*Looking up.*) Backwards and forwards, backwards and forwards. Went on for hours.

MEISIE: Ja.

MIEM: I think he can feel the forces of evil gathering around us. Oh, I wish to heaven that tonight was over! Anyone with any sense has taken precautions, of course. Locks and chains. Nailed the shutters down. But you mustn't worry my child. I'll sit right here beside you all night.

MEISIE: Yes, Ma.

MIEM: Sit up straight! How many times must I tell you? Pay attention to your posture if you want to get a husband.

(*They work on.*)

(*After a silence.*) That's two hundred altogether. I counted this afternoon. The other hundred and seventy are all full and stitched up. (*She bites the thread.*) There we go.

(*She hands the bag to MEISIE.*)

(*MEISIE takes the bag and adds it to the pile of completed sacks. As MIEM speaks, she is measuring out a length of hessian from the roll on the table.*)

Come on, Meisie, hold it straight for me.

(*MEISIE pulls the sacking out taut as MIEM cuts.*)

(*Cutting.*) These scissors are blunt again. You'll have to sharpen them. (*She glances at the sacks.*) Mostly cow dung. About thirty horse, and ten pig. We've not done too badly this month. And everyone wants to work their land with this early spring. (*Very friendly.*) Maybe I'll buy you a new dress. (*She puts the roll to one side, and sits with difficulty. The wind whines around the house.*)

MEISIE: Thanks, Ma.

(*Short silence. They work.*)

MIEM: What was that?

MEISIE: What, Ma?

MIEM: Sshht! I thought I heard something. (*She sits forward and listens attentively. She sighs and sits back.*) It's probably just the wind. (*Sweetly reassuring to MEISIE.*) Just branches scratching on the roof, that's all.
(*MEISIE stops work and listens.*)
And you'd better get a move on or you'll never finish all this.

MEISIE: Yes, Ma.
(*They work on in silence. MIEM puts her foot on a chair again.*)

MIEM: Tonight's definitely a night for keeping ears open. And eyes. Everywhere is dangerous tonight. (*She shakes her head and sighs deeply.*) There are some people who think that it's something...supernatural.

MEISIE: (*Frightened.*) What do you mean?

MIEM: (*Ominously.*) Something...unholy. Something hungry. Something roaming around; driven by the Devil's own lust, that can never be satisfied. Something filled with the power of hell.

MEISIE: That's horrible!

MIEM: (*Reassuring.*) There, there, child. The dominee and all the elders are praying tonight. Oh, no, it's slipped out again! Put my thread back through, there's a good girl.
(*She holds the needle out to MEISIE.*) It's a big eye, but my own aren't too good any more.
(*MEISIE stands and moves to the washstand lamp to see better.*)
(*Seeing MEISIE glancing through the curtains.*) And what are you spying at?

MEISIE: (*Quickly.*) I was looking at the lights.

MIEM: (*Rising, angry.*) Lights! I've told you not to!

MEISIE: Yes, Ma. (*Puts the thread through the needle, gives it to MIEM and sits quickly.*)
(*The wind rises and then fades again.*)

MIEM: (*Shaking her head and sighing. Sits heavily and begins work again. Silence. Suddenly, loudly, pointing at the window.*) It's WICKED!

MEISIE: Yes, Ma.

MIEM: And you still want to look?

MEISIE: Sorry, Ma.

MIEM: Have you no shame?

> (*MEISIE lowers her head.*)
>
> Your disobedience hurts me very much. You obviously don't remember how sick I got. All I could eat for two, whole weeks was barley soup.

MEISIE: (*Softly.*) I do remember, Ma.

MIEM: And it gave me cramps! So I felt even worse.

MEISIE: (*On the verge of tears.*) Sorry, Ma.

MIEM: And after all that, you still want to go and look?

> (*MEISIE cries quietly.*)
>
> Come on now, that's enough. What's done is done. (*Short silence.*) Get on with your work. (*She shakes her head and sighs.*) Idiots. (*She indicates towards the window.*) And on a night like this. Well, they won't believe us. It'll serve them right if it's one of their daughters that's the victim tonight.
>
> (*There is a loud sneeze from the ceiling.*)
>
> I hope he's not getting sick. He coughed for a month last spring. I worry myself sick. I just wish it would get warmer. (*Whining, almost pathetic.*) Your blood gets thinner as you get older. Every year, winter gets more difficult to bear.
>
> (*The sound of an old rattletrap car approaching.*)
>
> Who can that be at this time of night? (*Reassuringly.*) There, there, my child. I'll protect you. And if it comes to the worst (*Looking up at the trap door.*) he won't leave us in the lurch. (*Listening.*) It's stopped. Right in front of the door.

MEISIE: (*Frightened.*) Ma!

MIEM: (*Moving to the window.*) Stay calm, my girl. (*Peering out of the window.*) I can't see anything.

GERTIE: (*Off.*) Miem! Miem!

MEISIE: It's Miss Gertie!

MIEM: Sounds like it.

GERTIE: (*Hammering on the door.*) Let me in! Miem! Can you hear me?

MIEM: Is that you, Gertie?

GERTIE: Yes, Miem.

MIEM: Wait a moment.

(*MIEM bends and peers through the keyhole. Unlocks and unbolts the door, opens it. The circus music can be heard. GERTIE fumbles with the screen door and stumbles in. The screen door creaks and bangs shut behind her. She looks bedraggled. She is wearing a woolly green jacket and a hat perched over one eye. She is carrying a small, leather case.*)

GERTIE: Oh, thank goodness! (*Catching her breath.*) I almost died of fright!

MIEM: You poor thing. What's the matter, Gertie? (*Loudly to MEISIE.*) Shut the door and lock it! That disgusting music makes me sick!

(*MEISIE shuts the door and locks it. The music can no longer be heard.*)

(*Snorting and jerking her head in the direction of the door.*) Gongs and cymbals of Babylon! (*To GERTIE, with sympathy.*) Shame, Gertie, you look like a chick that froze in the nest!

GERTIE: Yes, well that little spring breeze is very deceptive! (*She removes her hat and places it on the table.*)

MIEM: Come and warm yourself up by the stove.

GERTIE: Hot stoves are very unhealthy. I know how to keep warm. (*She begins jogging on the spot, swinging her arms.*)

MIEM: For goodness sake, Gertie! There's a time and a place for everything.

(*GERTIE sits, reproached.*)

Some of the fruit trees are budding already, but, shame, this cold will kill them off.

GERTIE: 'Evening, Meisie.

MEISIE: 'Evening, Miss Gertie.

MIEM: Now tell me, Gertie. What are you doing out at this time of night?

GERTIE: Ag, Miem. Tonight's no time to be alone!

MIEM: (*Sighing and sitting.*) You can say that again. (*She picks up her sacking and sews.*)

GERTIE: I was just thinking how big my garden is and how far away my neighbours are...and then, in the quiet... I heard...noises. The whole house started creaking...and the shutters banged. It was awful.

MIEM: Shame, Gertie. Not surprising though.

GERTIE: And then I heard an owl screech in the garden. You know what the old people say...well, I just threw a few things together and... I'm sorry just to arrive on your doorstep like this!

MIEM: You did the right thing, Gertie. We all have to stand together tonight.

MEISIE: I heard an owl last night. In the tree outside my window.

MIEM: My poor girl. But don't you worry.

GERTIE: I don't want to be any trouble.

MIEM: No trouble at all, Gertie. You can sleep on the camp bed in my room. Meisie, take Miss Gertie's things to the room.

MEISIE: Yes, Ma. (*She picks up the hat and case and exits through the passage door.*)

GERTIE: (*Calling after her.*) Thanks, Meisie.
(*A soft, moaning wind can be heard.*)

MIEM: (*Softly.*) I'm glad you came. You're safe here with us, Gertie. (*She glances quickly at the passage door.*) When I think about that murderer...that rapist...creeping around the town again tonight, stalking his prey...

GERTIE: (*Suddenly.*) Miem! You're giving me the creeps.

MIEM: It's the uncertainty that's so disturbing. Where will he strike? Who will it be?

GERTIE: It's terrible! But there are some people who think that we're all making far too much of the whole thing. That Tok Pieterse's Rienie and Hannah Koen's Sannie just ran away...because they were unhappy and frustrated.
(*As MIEM speaks, MEISIE enters, sits and carries on sewing.*)

MIEM: I don't want to hear it! I just don't want to hear! It makes me too upset. All those poor fools who can't see the danger. (*She snorts.*) You must have seen that tent outside town on your way up here?

GERTIE: Yes. And there was a queue of people waiting to go in.

MEISIE: (*Excited.*) Are there a lot of lights and is the tent very big?

MIEM: (*Angrily.*) What do you care? (*To GERTIE.*) The idiots! But I wash my hands. We've warned them and warned them, but they won't listen. When I think of those dreadful people...vagabonds and criminals.

GERTIE: Not to mention the freaks. (*Shuddering.*) Just thinking about them...

MIEM: Freaks? What freaks?

GERTIE: In the little side-tent. You have to pay to go in.

MIEM: And how do you know...about the freaks?

GERTIE: (*Embarrassed.*) Me?

MIEM: Yes. You.

GERTIE: Well...

MIEM: Have you seen them?

GERTIE: Yes. (*Quickly.*) Just once.

MIEM: Gertie! How could you set foot in that place?

GERTIE: Well, you see, I wanted to go there and look at all the poor things...just to help me count my blessings. You know, Miem, looking at other people's misfortunes can make you feel very grateful.

MIEM: That's true enough. Sorry, Gertie. I thought you just went out of naked curiosity. Come, tell us all about these freaks. (*She nods in MEISIE's direction.*) It'll do her good. She's always unhappy with her lot.

MEISIE: Ma, that's not true.

MIEM: Oh, I know you never *say* anything. But you don't need to. I can see.

(*MEISIE turns her head away.*)

See? That's what I mean. (*She sighs and shakes her head.*) Well, come on, Gertie, tell us.

(*GERTIE rubs her hands quickly. After a short silence, she begins to speak. During the speech, she relives the experience. She is not recalling events, but recreating them in the present.*)

GERTIE: The tent is dark. Just torches in the corners. There the monsters are. There, behind a thin, rusted railing. People are walking past, slowly, from the left.

Every freak has got a sign. The first one of all is the 'Fat Woman'. She is half-lying, half-sitting on a pile of cushions. Her tiny eyes are swollen closed and her breath is heavy, and she smells dreadful: sour sweat between rolls of fat flesh.

(*MIEM and MEISIE watch her, motionless.*)

Then, the 'Carbuncle'. Naked to his waist, and covered in carbuncles, some as big as dumplings. There are even carbuncles amongst his hair, which is sparse and stringy. And on his forehead, right between his eyes, he's got a carbuncle horn. The next one is the 'Midget'. He is only knee-high, and is wearing a tailcoat and black top hat. Every now and then he bows and says, 'Good evening, ladies and gentlemen,' in a thin, husky voice, taking his hat off and pressing it to his chest. (*Suddenly she giggles a high-pitched giggle.*) He's adorable! I want to look at him for longer, but people are pushing from behind. Right at the back of the tent is a big, rectangular tank made of glass. There's a woman in it. Instead of legs, she's got a fish's tail.

MEISIE: Oh!

MIEM: Sssjut!

GERTIE: She is sitting with her arms on the edge of the tank. Her face is pale and her lips, so red. And her long, long locks of hair hang all the way to the floor. You can see her lower body through the water. Her tail moves slowly in the slimy green. And then, there's 'The Giant'. Tall and thin, so tall that his head nearly touches the top of the tent. He is swaying backwards and forwards, smiling. He never stops smiling. Now, there's the 'Bearded Lady'. She's a big-bosomed woman in a shiny, red dress. Her bushy beard is cut to an elegant point and hangs down low, almost brushing her thighs. She is playing a harmonium and singing a hymn. The last signboard says the 'Apeman', but there is nothing there, and people are starting to mutter, and to get angry. A shy man makes an announcement, telling us that the Apeman passed away recently. (*She looks at MIEM and MEISIE as if waking.*) There. That's all there is to tell.

MIEM: Awful!

GERTIE: (*Pressing her hands to her eyes and shuddering.*)
I'll never forget it!

MIEM: Poor wretches! (*To MEISIE.*) I hope that'll teach
you a lesson. So pretty and nicely made, but always such
a long face.

MEISIE: Ma!
(*The wind fades out, and disappears.*)

MIEM: Alright. Let's just leave it at that. (*Suddenly excited.*)
Gertie, you know, you've got me thinking. That circus
crowd was here last time. Who knows, but maybe it was
one of them!

GERTIE: No, Miem. Do you think so?

MIEM: I wish I'd thought of that before. I could have
mentioned it to the sergeant.

GERTIE: I'm sure he'll tumble to it on his own, Miem. The
sergeant is a very clever man.

MIEM: Yes, he is. *He* listened to us.

GERTIE: He went and got all those extra policemen and
dogs to patrol the whole area around town.

MIEM: Where did you hear that?

GERTIE: Town was full of them this afternoon. And on the
way home, I saw policemen with big dogs on chains.

MIEM: That is very good news!

MEISIE: Eina! (*She sucks her finger.*)

GERTIE: (*Sympathetically.*) Have you pricked yourself,
Meisie?

MIEM: Won't use a thimble.
(*The basket descends quickly during the following two speeches.*)
Basket, Meisie.

GERTIE: You're such a good girl to help your mother
like that.
(*MEISIE rises and unknots the rope from the basket.*)

MIEM: (*Looking at the plate in the basket, irritated.*) So, we
don't like tripe and trotters, do we? Scrape the plate
clean, my girl.
(*As the two older women speak, MEISIE scrapes the tripe
and trotters noisily into an enamel bucket.*)

GERTIE: (*Quietly, watching the rope ascend.*) How are things
up there?

MIEM: The same, Gertie, the same.

(Silence. MEISIE scrapes. The trap door slams shut.)

GERTIE: I wish tonight was over! I haven't slept well for weeks; such awful dreams.

MIEM: Really?

GERTIE: Yes.

MIEM: Sometimes a dream is just a dream…and sometimes it's a premonition.

GERTIE: Oh, please, don't even say that, Miem!

MIEM: It can be. Oh yes. I have a feeling…how can I explain? *(She beats her fist on her chest.)* A feeling deep inside, here. *(Ominously.)* Tonight, the forces of darkness descend on our town.

GERTIE: Dear God, protect us! If anything should happen, the church bells will ring.

MIEM: Is that so?

GERTIE: Yes. The lay sisters told everyone this afternoon, that when we hear the bells, we must all make our way to the church and congregate there.

(There is a loud knock at the door.)

MIEM: *(Whispering.)* Ssh. Don't move.

(MEISIE comes closer, and stands behind her mother, frightened. There is another knock.)

Who is it?

CONSTABLE: *(Off.)* Constable van der Riet, ma'am.

MIEM: I don't know any Constable van der Riet.

CONSTABLE: I know, ma'am. I'm not from hereabouts. I'm part of the deployed emergency forces. I've been sent over. You are very isolated out here. It could be dangerous.

(The three women look at each other.)

MIEM: Forgive me, Constable, but on a night like tonight, one can't be too careful. *(Peering through the keyhole.)* It's true. He is a constable. That's why Wagter didn't bark.

(GERTIE peers through the keyhole.)

GERTIE: *(Awed.)* You can tell he's a man of quality, even in the dark. Straight back, square shoulders. You can trust a man like that.

MIEM: Just a moment, Constable, I'm battling a bit with this lock. (*She unlocks the door.*) There. (*She opens the door.*) Please come in.

(*The CONSTABLE enters. He is wearing a helmet and round, dark glasses. In one hand he holds a white cane, and in the other, a Gladstone bag. There is dead silence as the women stare at him. Through the open door, the circus music can be heard.*)

CONSTABLE: (*After a pause, he smiles.*) As you can see, I'm completely blind. And you find it disturbing. How can a blind man keep an eye on things? Ladies, please let me reassure you. They don't call me smell-a-rat van der Riet for nothing. (*Tapping a finger against his nose.*) There's nothing I haven't sniffed out with this.

MIEM: (*Unsure.*) Good evening, Constable.

GERTIE: Evening, Constable.

CONSTABLE: Wait a moment. Don't introduce yourselves. (*He sniffs the air. MEISIE closes the door, the two women stare at him.*)

There are three ladies here if I'm not mistaken.

GERTIE: Yes, that's right!

CONSTABLE: (*Raising a hand for silence.*) Please. (*Muttering.*) So strange…they told me that there were only two living here…oh, well, let's continue. (*He walks closer to the women, and stands in front of MIEM, drops his head and sniffs as if a scent came from below.*) Let's see…late middle age…married with children.

(*MIEM claps her hand over her mouth in amazement.*)

(*Standing in front of GERTIE, sniffing.*) Middle-aged. Unmarried.

(*GERTIE catches her breath.*)

(*Standing in front of MEISIE.*) Young girl. Unmarried.

GERTIE: (*Softly, to MIEM.*) Incredible! I must congratulate you, Constable. You were absolutely dead right!

MIEM: How can you tell, Constable?

CONSTABLE: Very simple. Each scent is different. Older women give off a…a certain… (*He sniffs in MIEM's direction.*) …certain smell. But an unmarried woman:

(*He sniffs in GERTIE's direction, she giggles and recoils.*)...
she has a sharper fragrance. Slightly...sour. A bit like
curdled milk.

GERTIE: Oh!

CONSTABLE: Nou ja... (*Using his stick to navigate, he moves
slowly towards MEISIE, sniffing lightly.*) ...a young lady
gives off a very particular perfume. (*Next to MEISIE.
He breathes deeply as if smelling a flower. MEISIE gets
embarrassed and drops her head.*)

(*Pleasantly.*) The scent...of a young lady.

MIEM: Very interesting, Constable.

GERTIE: (*Slightly sourly.*) Yes, it is.

CONSTABLE: I hope that I have given you some
reassurance. My other senses are just as developed.
I knew, for example, that it was full moon tonight.

MEISIE: (*Enthralled.*) Does the moon have a smell too?

CONSTABLE: (*Smiling.*) No, Miss.

MEISIE: (*Giggles, repeating softly.*) Miss...

CONSTABLE: It's just that, at full moon, everything is
different.

MEISIE: (*Eagerly.*) How... How is it different?

CONSTABLE: The crickets sing louder. Night flowers
smell sweeter. And the adders slide faster through the
veld-grass.

GERTIE: And you can sense all that?

CONSTABLE: Yes, I can.

GERTIE: (*Folding her arms.*) Amazing.

MIEM: Please, sit down, Constable. Oh, where are my
manners? I haven't introduced myself. I'm Mrs Fick.

GERTIE: (*Moving quickly to him and taking his arm.*) There we
go. Just watch out for the corner of the table. That's it.
(*She pulls a chair out.*)

CONSTABLE: (*Shortly.*) I can manage, thank you.

GERTIE: (*Reproached.*) Just as you please.

MIEM: How about a nice cup of coffee, Constable?

CONSTABLE: Thank you. (*He sits.*) Three sugars and a
drop of milk. (*He pushes his bag under the chair.*)

MIEM: Meisie, make the Constable some coffee. You heard
what he said, right? Three sugars and a drop of milk.

MEISIE: Yes, Ma. (*She moves to the stove.*)
 (*MEISIE is watching the CONSTABLE surreptitiously, as are GERTIE and MIEM. He sits quite still and stares ahead of him. After a few moments of silence, he bursts out laughing.*)
MIEM: What is so amusing, Constable?
CONSTABLE: Something. (*He laughs.*) It just struck me suddenly. (*Suddenly serious.*) I'm sorry. Forgive me, please.
GERTIE: You can share it with us. A little joke would do us the world of good.
MIEM: You can say that again, Gertie.
CONSTABLE: I'm sorry. It's personal.
MIEM: (*Affronted.*) Oh. (*She looks at GERTIE. An uncomfortable silence ensues.*)
GERTIE: Where are you from, Constable?
CONSTABLE: Here, there and everywhere. I never spend much time in the same place. I get used for…
 special cases.
MIEM: So, you were obviously here to investigate the disappearances, Constable?
CONSTABLE: Yes, that's right. The missing persons. But I've not been briefed in any detail. They always say, the less you know the better.
MIEM: (*Excited.*) Well, I can tell you everything! It all started two years ago. Meisie!
MEISIE: (*Getting a fright.*) Yes, Ma?
MIEM: Take the bags that we've finished and pile them on the ones lying outside.
MEISIE: But I'm making coffee for the Constable.
GERTIE: Don't worry. I'll do it.
MIEM: Meisie, do as I tell you.
 (*MEISIE goes quickly to the sacks in the corner.*)
 (*Behind her hand.*) She is still so young and innocent. There are some things I'd rather she didn't hear.
 (*MEISIE drags the sacks to the door.*)
 Meisie, leave the door open so we can hear if you scream.
CONSTABLE: Very sensible.
MEISIE: Yes, Ma.

(*She opens the door and drags the sacks out. The screen door bangs shut. Circus music. The CONSTABLE turns his head as if listening to it.*)

MIEM: It all started two years ago…

GERTIE: (*Coming closer, eagerly.*) With Sannie Koen!
(*The CONSTABLE turns his head in their direction.*)

MIEM: At first, everyone thought she'd just run away because her mother's hypochondria got too much for her. But, (*Ominously.*) what did we hear next? She didn't take a suitcase, and she left barefoot…in her confirmation dress.

GERTIE: I ask you! Who runs away without any shoes on?

MIEM: (*Turning to the door.*) Everything alright, my girl?

MEISIE: (*Outside.*) Yes, Ma.

MIEM: Stack them neatly! Oh, that dreadful music! I'm sure it worries you too, Constable. Where was I? Oh, yes: exactly a year later, it was Rienie Pieterse…everyone said it was because her father had her so much under his thumb. But you know what, Constable? With her, it was exactly the same.

GERTIE: Barefoot in her confirmation dress.

CONSTABLE: (*Suddenly very upset.*) I don't believe it!
(*Jumping up.*) Yes, yes, yes. It's exactly what I suspected!

MIEM: What do you mean?

CONSTABLE: (*Sitting.*) I'm sorry. I can't tell you.

GERTIE: (*Whispering.*) Top secret information?

CONSTABLE: Yes, Miss. Top secret. (*Disturbed again.*) Didn't anybody notice anything suspicious?

MIEM: As I said, everyone just turned a blind eye. But Gertie and I discussed the matter between us.

GERTIE: Yes! And we went straight to the sergeant, and when we'd told him everything, he looked at us and said…oh, I'll never forget it…he said:

MIEM/GERTIE: Ladies, you may be on to something. I also smell a rat here.

MIEM: And that's why they started searching. They looked in every nook and cranny.

GERTIE: They even had nets and frogmen in the dam.
(*She goes back to the stove.*)

MIEM: And then they found Sannie Koen's hair ribbon in a thorn tree. (*Pointing.*) Just outside the town. And, as you know, Constable, it was the same night of the year in both cases: the last night of August.

GERTIE: That's why we were so grateful...

MEISIE: (*Appearing at the door.*) I'm finished, Ma.

MIEM: Well done, my girl.

GERTIE: I was saying, how grateful we are to have you with us tonight. (*She walks carefully towards the CONSTABLE with an over-full cup of coffee.*)

CONSTABLE: I'm glad to be of service.

MIEM: And close the door, Meisie!

GERTIE: Here, Constable. Sorry...I've spilled a bit in the saucer.

(*MEISIE closes the door and the music becomes inaudible.*)

CONSTABLE: Not to worry, Miss. (*He clears his throat.*) I hope that you won't take offence, but it seems to me that you've been blind to the real issue here.

MIEM: How is that, Constable?

CONSTABLE: (*Shortly.*) I've said too much already. Let's just leave it at that. (*He claps his hands together.*) Well, if you are the ones who started all the investigations, that's obviously why I'm here. Perhaps the person, or persons...

GERTIE: Oh no, Constable! Is there more than one?

CONSTABLE: One never knows. Anything is possible.

MIEM: That's true. (*To MEISIE.*) What are you doing over there at the window? Sit down and finish your sewing.

MEISIE: Yes, Ma. (*She sits and works.*)

MIEM: Sorry, Constable. You were saying, about this person or persons...

CONSTABLE: I was saying that perhaps he...

GERTIE: Or they!

CONSTABLE: Exactly. Perhaps they bear a grudge against you and the lady here.

GERTIE: No!

MIEM: How horrible!

CONSTABLE: You could be targets.

(*MIEM, GERTIE and MEISIE gasp simultaneously.*)

But you mustn't upset yourselves. I'm here to see that nothing happens to you.

MIEM: I can't tell you how grateful we are, Constable.

CONSTABLE: Not at all, Mrs Fick. It's just part of the job.

MIEM: It's...appalling.

CONSTABLE: (*Taken aback.*) I beg your pardon?

MIEM: Just to think that at this very minute we are probably being watched...every word we are saying being overheard.

GERTIE: By a person, or a group of people with revenge on their minds!

MIEM: And...I already have so much to deal with. It's all becoming too much for me. (*She groans and buries her face in her hands.*)

GERTIE: Oh, poor Miem.

MIEM: (*To MEISIE.*) Come with me, my child. (*She stands heavily.*) Excuse me, Constable, I'll be back in a moment.

CONSTABLE: Of course, Mrs Fick.

(*Silence. MIEM disappears through the passage door, MEISIE creeping behind her. GERTIE watches the CONSTABLE, who sits still, staring in front of him.*)

GERTIE: That poor woman suffers so much. (*Quietly.*) She never talks about it, but she's not well at all. She's got diabetes and water on her knees. And then of course there's him. (*Indicating ceiling.*)

CONSTABLE: What do you mean, Miss?

GERTIE: Her husband. He went up there seven years ago, just after the Depression. She has to wait on him, hand and foot, though she never sees him and he doesn't say a word. Not even a please or thank you! But just listen to me rattle on! (*Shy laugh.*) Lord, where are my manners? I haven't introduced myself. I'm Gertie Vermeulen, physical education teacher at the local school.

CONSTABLE: Pleased to meet you. (*He indicates passage door.*)
I hope I haven't upset her.

GERTIE: Not at all, Constable. Beating around the bush certainly doesn't make your work any easier. If we are in serious danger from this person, or persons threatening

us, then it's your duty to let us know! (*A sound of anxiety escapes her lips, and she presses her hand over her mouth.*)

CONSTABLE: What is it, Miss?

GERTIE: Nothing at all. I just feel a little…dizzy. (*High laugh.*) There! All better. You know, Constable, when I think of Miem, I realise how lucky I am. I may be a bit of an old maid with neither kith nor kin. But when I look around me and suddenly that doesn't seem like such a bad thing to be. I get great comfort from that thought. (*Short silence.*)
And what about you, Constable?

CONSTABLE: What about me, Miss?

GERTIE: Are you married?

CONSTABLE: No, I'm not.

GERTIE: I see. (*Silence.*) But surely there's someone special… (*The CONSTABLE smiles and shrugs.*)
So. You're footloose and fancy-free?

CONSTABLE: I suppose you could say that, Miss.

GERTIE: You seem very particular though, very careful. And that's very good, I think.

CONSTABLE: Well, you know what the *boere* say about marriage and livestock, don't you?

GERTIE: (*Coquettish.*) Choosing a wife is not the same thing as choosing a horse?

CONSTABLE: That's it!

MIEM: (*In the passage.*) That feels much better.
(*GERTIE giggles.*)
(*Appearing at the passage door.*) And what's so funny?

GERTIE: (*Shyly.*) Oh, nothing really.
(*MEISIE enters, moves to the window and looks out.*

CONSTABLE: We were just discussing affairs of the heart. (*Gallantly.*) Miss Gertie and I have discovered that we have quite a bit in common: we're both to careful and choosy to get married!

MIEM: Really? You mean you're not married either?

CONSTABLE: No, I'm not.

MIEM: (*Thoughtfully.*) I see. (*She sees MEISIE at the window.*) Come away from that window! (*Very friendly.*) Have you eaten yet, Constable?

31

CONSTABLE: Yes, thank you, Mrs Fick.

MIEM: That's a real shame. Meisie is the most wonderful cook. She makes the best stew in the district and her cakes are definitely the lightest. And as for her roast leg of lamb, and her little fruit tarts…mmm! If you get hungry later, she'd be delighted to make you something. Nothing would be too much trouble, isn't that right, Meisie?

MEISIE: (*Reluctantly.*) Yes, Ma.

CONSTABLE: Are you feeling better, Mrs Fick?

MIEM: Yes, thank you. My corset was just a bit tight. I have to watch my circulation. It's not always what it should be. That's why I rely so much on Meisie. And I know I can because she's so hard-working and always so willing. Isn't she, Gertie?

GERTIE: (*Reluctantly.*) She is a good girl. (*Suddenly frightened.*) What's that?

(*The sound of a dog sniffing around outside.*)

MIEM: What?

GERTIE: Something scratching at the window.

CONSTABLE: Don't panic.

GERTIE: Do you hear it?

CONSTABLE: (*Standing and listening attentively.*) A big animal. Short snout. Stub tail.

MIEM: Wagter! Our pitbull!

GERTIE: (*Clapping her hands.*) Incredible!

MIEM: I can't believe it! Everything down to the length of his tail!

CONSTABLE: (*Sitting.*) Glad to be of service.

MIEM: (*Loudly, in the direction of the window.*) *Voetsek*, Wagter! (*To the CONSTABLE.*) He was…is my husband's dog. I never got along with him! (*Silence. Then, very friendly.*) As I was saying, Meisie does everything in the house. After the Depression, we couldn't afford servants. She makes the beds, sweeps the floors, does dishes, washes, irons…

MEISIE: (*Uncomfortable.*) Ma…

MIEM: Come on, Meisie. You really are far too modest. Don't know how to take a compliment! And of course,

she helps me so much with the sack-making! (*She laughs.*) But a man's only young once, hey? And a pretty face is much more important than all these virtues! But she's got that too, you know! She looks like an angel.

MEISIE: Ma!

MIEM: No need to be embarrassed, my girl. And her hair is so long and soft. I wish you could see her, Constable. A feast for the eye. Perhaps you'd like to feel her hair? Meisie, let the Constable feel your hair.

MEISIE: (*Tearfully.*) Ma!

CONSTABLE: You really don't have to...

MIEM: She's slim and fit. (*Suggestive.*) But her hips are broad enough. (*Suddenly getting an idea.*) Good Lord, Gertie! We never made up your bed!

GERTIE: I can do it myself.

MIEM: Absolutely not! Come on, I'll help you.

GERTIE: Can't it wait till later?

MIEM: No, it's getting late! (*She makes a meaningful gesture that only GERTIE sees.*) Come on.

GERTIE: (*Very reluctantly.*) Oh, alright!

MIEM: Meisie will keep you company, Constable. She's a little shy, but if you give her some encouragement she'll creep out of her shell. Come on, Gertie!
(*GERTIE follows MIEM out. They disappear through the passage door. The CONSTABLE sits dead still. MEISIE is uncomfortable and fidgets.*)

MEISIE: I'm sorry.

CONSTABLE: What for, Miss?

MEISIE: I don't know what to say. I'm not used to people.

CONSTABLE: Really? Don't you get visitors?

MEISIE: Not really.

CONSTABLE: I don't understand why not...such a lovely young lady...

MEISIE: I don't know. (*Short silence.*) I think it's the dung.

CONSTABLE: The dung, Miss?

MEISIE: There's a lot of it on the lawn. Big heaps of dung. Like haystacks. All kinds: cow dung, pig dung, horse dung. The farmers bring it to us at the beginning of each month. Lorries and wagons full of dung. At the end of

the month it gets put in bags... (*She gestures to sacks.*)
...and we sell it. For fertiliser. My mother says it keeps us
alive. The dung. (*Suddenly shrill, almost hysterical.*) But it
stinks! (*Instantly ashamed.*) You can probably smell it.

CONSTABLE: It doesn't worry me, Miss.

MEISIE: It doesn't smell so bad tonight because it's cold
and everything is shut. But in summer it's terrible. The
stink...and the flies. Clouds of flies. And bluebottles.
Big, shiny bluebottles. (*Silence.*) I...planted rose trees
outside my window. (*Silence.*) And that's why no one
comes to visit. The smell is so terrible. Who would want
to drink tea? The flies have got dung all over them.
They walk over the cakes and fall in the milk. (*Short
silence. She smiles.*) Last year, Danie Venter came to visit.
One Sunday. The wind was blowing the right way, you
see. It blew away all the flies and the whole house
smelled of roses.

CONSTABLE: (*Interested.*) Yes? And then?

MEISIE: (*Sadly.*) Then the wind changed.
(*Silence. MEISIE works on her sack.*)

CONSTABLE: But don't you go out? The town's not very
far away?

MEISIE: My mother needs me here. She's only got me.

CONSTABLE: And is there really so much to do here?

MEISIE: Yes. I never get all the work done. There's always
dust all over everything. The walls are thin and full of
cracks, so everything outside comes inside. I dust and
sweep, dust and sweep, but it doesn't help. And every
day I have to wash and iron, because our clothes smell of
dung. And the windows have to be cleaned every day...
(*Almost in tears.*) Because the flies leave dung-tracks on
the glass... Food, slops-bucket! Sacks! My hands were
soft once. (*She stretches out her fingers.*) Now I've got
calluses on my fingertips. (*She presses her hand to her
mouth.*)
(*Silence.*)
We were very rich once. I remember: I had a different
dress and a hat for each day of the week. And now... Ma

says people feel sorry for us. (*Almost defensive.*) Ma buys me a new dress every year! (*Sadly.*) But just one at a time. (*Softly, sorrowfully.*) It gets thin so quickly...and faded. (*Soft.*) I feel ashamed.

CONSTABLE: (*With deep sympathy.*) I am sorry, Miss.

MEISIE: (*Suddenly laughing.*) It's funny. No one has ever called me Miss before! (*Laughs.*) Miss...

CONSTABLE: May I ask what your name is?

MEISIE: (*Embarrassed.*) Meisie. (*Quickly.*) But that's not my real name.

CONSTABLE: What is it? Your real name?

MEISIE: (*Very shy.*) Margareta.

CONSTABLE: (*Sincerely.*) You have a lovely name, Margareta.

MEISIE: (*Watching him. After a silence.*) I've got another name.

CONSTABLE: What is it?

MEISIE: Johanna. (*She laughs shyly, stands and walks to the window while she half-speaks, half-sings.*) Margareta Johanna, Margareta Johanna, Margareta Johanna. (*She laughs, pulls the curtains aside and peers out.*)

CONSTABLE: Where are you now, Miss?

MEISIE: (*Excited.*) Here, at the window. I'm looking at the big tent and all the lights.

CONSTABLE: The circus?

MEISIE: (*Turning, suddenly alarmed.*) Please, don't tell my mother!

CONSTABLE: I won't.

MEISIE: Promise. Promise me.

CONSTABLE: I promise.

MEISIE: (*Relieved.*) And I won't look again. Really.

CONSTABLE: I don't mind. I like the circus too.

MEISIE: (*Excited.*) Have you seen it? (*Embarrassed.*) I... I'm sorry.

CONSTABLE: (*Laughing.*) No. But I wish I had. And you, Margareta? Have you?

MEISIE: (*Nervously.*) Yes.

CONSTABLE: Tell me about it.

MEISIE: No! I'm not allowed to talk about it! I'm not even supposed to think about it! Thinking is doing!

CONSTABLE: (*Almost seductive.*) But you can tell me. Just this once. I'm a stranger. And I'm blind.

MEISIE: (*Uncertainly.*) I don't know…

CONSTABLE: (*Whispering.*) No one will ever know.

MEISIE: Alright then, I'll tell you and then forget all about it. (*She closes her eyes tightly.*) Forever and ever.
(*Silence. She begins to speak and as she does, relives the experience. Soft gusts of wind can be heard, increasing slowly in volume.*)
A few years ago, the circus came here. Just like now. But it was a hot night. 'An early summer,' my mother said. 'It'll bring drought and disease.' (*Softly.*) It's very humid in the house. We've opened all the windows, and gone to bed. Suddenly, I wake up. I'm lying in the dark and listening to the music. And the music seems to get louder and louder. There are branches scraping on the roof, and the curtains are swaying in time with the music. I go and stand at the window, and from there I see the tent. The big tent covered in tiny lights. The music is getting louder and louder. Suddenly, I'm climbing out of the window, jumping down amongst the roses, slipping through the garden gate and walking to the fairground. Just like that. Barefoot over the thorns. I'm walking between the cages. A tiger roars. A monkey screams. And now I'm standing close to the tent.
(*She laughs.*) There's a little hole, and I peep through. (*She makes a 'hole' with her finger and thumb and peers through it.*) First one eye, then the other. (*Silence. Then enchanted, as if seeing it all again.*) I see a man with long black hair and a shiny cloak. There's a girl with him. He holds a saw up for the crowd to see, and calls someone over to feel how sharp it is. Fat Oom Soon comes up, and everyone laughs because he cuts his finger. The man points to a long box and then bangs the lid of the box open. The pretty girl begs and pleads, and falls on her knees in front of the man. He grabs her wrists and drags

her to the box, throws her in and closes the lid. Her head is sticking out one side, and her feet out of the other. The man starts to saw and saw, and saw. The girl screams. The saw is covered in blood, and the box is cut down the middle, but her head and feet are still moving. The man throws his cloak over the box and says some magic words. He takes off the cloak and opens the lid. (*Overcome with happiness.*) The girl jumps out and everything's alright! She's whole again! Everybody is shouting and whistling! She stretches her arms out wide. (*She lifts up her own arms and smiles.*) The man opens a cage and birds fly out. All sorts of birds; so many colours. They are hanging in the air over her. (*She looks sad, and lets her arms sink slowly. The sound of the wind stops.*) Then I felt a hand on my shoulder. It was my ma. She was wearing a dressing gown, and her hair was still in rollers. She'd heard the garden gate. My Ma brought me up very well. And every year she warned me not to go to the circus. I was disobedient. She got sick...from worry. She could only eat barley soup for a week. It's the music. I mustn't listen to it.

GERTIE: (*Off.*) That's what I say as well!

MIEM: (*Off.*) Exactly.

(*They enter. They are in deep conversation. MEISIE looks down and works on her sack.*)

GERTIE: Yes. Just scratched around.

MIEM: (*Excited.*) I told them to dig up, turn everything over, but I wasted my breath! I'm sure you agree, Constable. But they wouldn't listen!

GERTIE: No, they wouldn't.

(*A soft, moaning wind can be heard.*)

MIEM: And now the trail's cold. They wouldn't search properly, Constable. Of course, we're speaking about the disappearances. The investigation after the disappearances. Oh, well. (*She sighs.*) What can one expect? (*She sits at the table and smiles.*) It looks as if the two of you have got along very nicely, haven't you?

MEISIE: (*Frightened.*) What is it?

MIEM: Don't worry, it's only the wind, my child. And branches on the roof.
(*Short silence.*)

GERTIE: I feel a draught. Is something open?

MIEM: Don't worry! Everything's shut up. The wind is just blowing through the cracks.
(*Short silence. Then urgently to the CONSTABLE.*) And the wells, I said! Look in the wells. (*She sighs.*) But nobody listened. What more can a person do?

GERTIE: Yes. Your hands were tied.

MIEM: And then there was Tant Salie's dream. Very old, and her eyes already white with the cataracts. But let me tell you, there has not been one drought, or death, or flood that she hasn't predicted.

GERTIE: It's true, Constable. What she sees, happens.

MIEM: And then she dreamed. Of a girl. Under water. She couldn't say whether it was Rienie or Hannah's Sannie. But no one would pay any attention! (*Whispering.*) Believe me, Constable, I have my suspicions.

CONSTABLE: Really, ma'am?

MIEM: Apart from the awful circus people there are things going on in that town…but wait. I'm talking too much.
(*The wind softens and dies away.*)

GERTIE: (*Eagerly.*) Oh, come on, Miem! It's not as if you were gossiping! You are talking to the law! Tell the Constable!

MIEM: You are probably right. Constable, I could tell you a thing or two. And about very prominent people, let me tell you!
(*A terrifying cry is heard.*)

CONSTABLE: What was that?

MIEM: Not to worry, Constable. It's just my husband. It's the time of night that he always gets rid of his bottled up feelings. Otherwise he's dead quiet.

CONSTABLE: And how long…has it been like this?

MIEM: Since the Depression. It was too much for the poor man. (*She sighs.*) Sixpence for a sheep!

CONSTABLE: Do you see him often?

MIEM: I haven't laid eyes on him for seven years. (*Tearfully.*) It's a great strain on me.

CONSTABLE: Does he ever go out? Is there a way that he can get out? Perhaps through a back door or a loft door?

MIEM: Why do you ask, Constable?

CONSTABLE: I'm just asking, ma'am. (*Suddenly firm.*) Please answer my question: is there a loft entrance?

MIEM: Yes, there is. And so what? He locked it from the inside. That door has not been opened for seven years!

CONSTABLE: So, he has the key?

MIEM: (*Suddenly very angry.*) Just what are you trying to say, Constable? Do you think my husband is a suspect? My poor Gabriel, who wouldn't hurt a fly! We open our house to you and this is how you repay us!

CONSTABLE: Forgive me, ma'am… I didn't mean…

MIEM: You must think we're stupid. Pretending to protect us! (*She snorts.*)

GERTIE: Aag, come on, Miem.

MIEM: Yes, pretending to protect us. But what he really wants to do is snoop around my house! Like a bloodhound.

CONSTABLE: Ma'am, I assure you…

MIEM: Gabriel is a good man! A sweet, mild man! Upright and honest! From an excellent family! He's always been…a bit moody, but what's wrong with that? Does it make him a monster? Oh, yes I know what people say about him…that he's not…quite right up here. (*She taps her head. Furious.*) Gossips! Troublemakers! And you believe them! Constable, I think that you had better leave. You are no longer welcome in my house!

GERTIE: Are you being serious, Miem?

MIEM: Keep out of this! It's my husband that is being…slandered!

CONSTABLE: (*Standing up. Angry. Moving to the door.*) I am going, ma'am. (*He turns at the door and drops his stick.*) But please at least allow me to explain myself. I don't wish to leave like this.

MIEM: (*Surly.*) Oh, say your say!

CONSTABLE: (*Angry.*) It's my job to ask questions. And I am genuinely concerned for your safety. Whatever you might think. I just wanted to discover...whether there was another door to the house. Another entrance. So that I could be on my guard. Now I know of all the dangers. The door could easily be forced open...someone could slip inside...overpower your husband...climb down, and before we know it, he, or she is among us.

GERTIE: Oh dear God!

MIEM: Constable...perhaps I was a little hasty. I can see that you do have our interests at heart. You must please forgive me. I have a rather short fuse. I get it from my mother's side. Please, stay Constable. We would all appreciate it.

GERTIE/MEISIE: Please, Constable.

(*He doesn't answer. He stands and stares ahead of him.*)

MIEM: (*After a pause, over-friendly.*) Tell us, Constable, have you had previous experience of cases like this? Disappearances, I mean.

CONSTABLE: Oh yes. That's what I specialise in: missing persons.

MIEM: Really?

(*MEISIE pricks her finger. She catches her breath and sucks her finger.*)

(*To the CONSTABLE.*) With missing persons, Constable?

CONSTABLE: I can't see. That's when they use me. When there's nothing to see. When someone disappears from sight.

GERTIE: That's wonderful.

CONSTABLE: Someone may not be visible to the naked eye, but there are other senses that do the work.

MIEM: Very interesting.

GERTIE: Please, tell us something about how you work.

CONSTABLE: Well...seeing is believing. It's difficult to explain.

MIEM: (*Over-friendly.*) Please come and sit down, Constable.

CONSTABLE: Alright...

MIEM: Then I'll get you another cup of coffee. (*She stands and moves to stove.*)

CONSTABLE: I wonder if someone could help me…you see, I am lost without my stick.

GERTIE: But of course, Constable. (*She picks up his stick and gives it to him, takes him by the arm and leads him to a chair.*)

CONSTABLE: (*Jerking his arm away.*) Thank you, Miss, I can manage.

(*He moves slowly to his chair, tapping with his stick. GERTIE looks at MIEM. They shake their heads in sympathy. GERTIE sits back down. She is a little tearful, and dabs at her eyes with a handkerchief. The CONSTABLE sits down.*)

GERTIE: (*Moved.*) I know that it can't be easy. Although you make so little of it.

MIEM: Yes. It must be a great trial for you. Tell me, Constable, if you don't mind my asking. Have you always been blind? Or did it happen later on in life?

GERTIE: Miem, how can you ask a thing like that!? That's so private!

CONSTABLE: I don't mind in the slightest, Miss. No. It wasn't always like this. I was six.

MIEM: Really? And how did it happen?

GERTIE: Miem! You don't ask things like that!

CONSTABLE: I really don't mind. I'm quite happy to speak about it. There's nothing I like more. If people ask me, I tell them. And I never mind repeating the story. Over and over and over. Anywhere and any time. Because it's all that I can still see. What happened just before it. Beyond that, I can only dimly remember things. The farm, dam, faces, cats, sunflowers. But not very well. And every year it gets fainter. The dam has almost completely disappeared. But what happened that day, that stays with me. I don't tell it. I see it. In front of my eyes. (*Warningly.*) Don't interrupt me. No one must ask me anything.

(*The soft sound of a wind that gets slowly louder. The CONSTABLE's story is more of a reliving than a retelling of the past. MIEM, MEISIE and GERTIE, his audience, hang on every word.*)

There's a gale blowing up. The shutters are banging. The house rocks and creaks. I'm frightened and I go to find

my mother. She is sitting with my father on the veranda. My father is wearing a light suit and my mother has a shawl with fringes and purple flowers. The wind is blowing her hair. My mother and father are each holding shards of smoked glass. My mother is looking at me. Her hair blows over her face. I can only see one eye. 'Go to the kitchen and get yourself some glass,' she says with her mouth full of hair. I go to the kitchen. I think that the glass might be for the wind. Tant Hannie is making mulberry jam in the kitchen. The mulberries have made her fingers red. She sucks her forefinger and wipes the others clean with a white cloth. She gives me a long, sharp piece of smoked glass. 'Hold it between your thumb and big finger,' she says. She asks where my brother is, and then there he is, in the doorway. She gives him glass as well. She squats down and opens her arms. We come closer. 'You don't know about it, do you?' she whispers and laughs. 'The solar eclipse. It's nearly here. The glass is for looking through. Otherwise the sun will burn you. If you look carefully, you'll see…' She glides one hand with shining rings over her other hand… 'how the shadow of the moon slides over the sun.' We wanted to get as close to the sun as possible. We climb up the peach tree and sit on the roof. The wind is roaring in our ears. In the back garden, the chickens are cackling and being blown against the fence and the quinces are falling like hail. The flowers are flying out of the front garden. The wind is pulling me. I get a fright and drop my piece of glass and it falls onto the veranda roof. I can see my mother in the flowers. She is holding her shawl tight against her chest. She puts a hand over her eyes and looks up to us. Her shawl flaps behind her and her hair is blowing high above her head. 'Be careful!' she shouts, but her voice seems far away and faint. Then she disappears again. A tile keeps rattling and the air is full of leaves and feathers.

(*The wind sound stops.*)

Then – quite suddenly – everything's quiet. Nothing stirs.

And my brother says, 'Look' and he peers through the glass with one eye. I say, 'Give it to me,' but he won't. So I cup my hands over my eyes and I look up. I see a shadow take a bite out of the sun. And as I look and look, the sun gets smaller. Just darkness and a sickle-sun. And then suddenly, everything is black. I hang onto the ridge of the roof and wait for the sun to come back. I wait for a long time. Then I hear the chickens and the banging doors again. My brother climbs down past me. I can hear him in the branches. They are all looking for me, calling me, and then my mother says, 'Get down from the roof!' And I wonder how they can see me in the pitch dark. (*Silence. He places his two forefingers slowly on the lenses of his glasses.*) You see, the sun burnt out my eyes. (*Suddenly uninvolved.*) And that is how it all happened.

MIEM: Horrible.

GERTIE: A real tragedy.

CONSTABLE: (*Smiling.*) From then on I only remember those faces. All women look like my mother or Tant Hannie to me, and all the men like my father. Boys look like my brother. Or like me. Because on the way to the kitchen, I had a quick look in the hall mirror. But babies, girls, young ladies and old people... I just have to make them up.

GERTIE: How interesting! And how do you decide who looks like your mother and who like your aunt?

CONSTABLE: The voices.

GERTIE: Really? (*She giggles.*)

MIEM: Such a dreadful thing to have happened to you. Your mother must have been heartbroken.

CONSTABLE: Yes. She was.

GERTIE: But you've risen above it. I can't tell you how much I respect you, Constable.

CONSTABLE: Thank you, Miss.

MIEM: Drink up your coffee, Constable, it's getting cold.

CONSTABLE: Yes.

(*The CONSTABLE feels about the surface of the table. He can't find the coffee cup. MIEM and GERTIE watch him*

43

silently. After a while, he finds the cup. MIEM and GERTIE both nod in imperceptible approval. He picks up the cup and saucer and takes a sip.)

MIEM: I hope it's not too cold.

CONSTABLE: Not at all, ma'am. (*He takes another sip.*)

MIEM: (*After a short silence.*) Constable, about what just happened... I just want to say I'm sorry. It was all a misunderstanding, and if there is anything that I can do to make it up to you...

CONSTABLE: Well, there is a little favour you could do for me.

MIEM: Of course, Constable. No problem at all. How can I help you?

CONSTABLE: As I said, I have a definite image of older women...but not of young girls. I don't know how they look. I'd so like to see one.

GERTIE: What do you mean by 'see'?

CONSTABLE: (*Smiling and moving his fingers like feelers.*) With my fingers, Miss, with my fingers.

GERTIE: Oh!

CONSTABLE: I'll be able to get a faint picture that way.

MIEM: But of course, Constable. With pleasure. Meisie, tell the Constable what a pleasure it would be...
(*MEISIE says nothing.*)

CONSTABLE: Of course, if the young lady doesn't want to...

MIEM: Not at all. She's just shy, aren't you, Meisie? (*Urgently.*) Aren't you, Meisie?

MEISIE: (*Softly.*) Yes, Ma.

CONSTABLE: Thank you, Miss. Would you mind coming and standing in front of me...
(*MEISIE walks slowly to the CONSTABLE and stands in front of him.*)
(*He puts his hand out and touches her hair.*) Good. Kneel down. Here. Right in front of me.
(*MIEM and GERTIE watch, motionless. MEISIE kneels slowly. He puts out his hand and strokes her hair. MEISIE closes her eyes and drops her head backwards slightly.*)

(*Muttering.*) Pretty…so pretty…

(*He touches her face, gently stroking with the back of his fingers, over her eyelids, and touches her lashes with the tips of his fingers. Then he strokes her lips with a fingertip. His hands slide down her neck. When he has finished he places his hands in his lap.*)

MIEM: (*Proudly.*) She's pretty, isn't she?

CONSTABLE: Yes, ma'am.

(*MEISIE stands up and moves slowly back to her chair. There is a short silence. MEISIE resumes work on her sack. The other women look at the CONSTABLE. He stares ahead. The trap door bags open. MEISIE looks up. The slops bucket is slowly lowered.*)

MEISIE: Look, Ma. Here it comes.

MIEM: (*Loudly, looking up.*) Be careful! It's been over two days! (*The women watch the bucket coming down. It descends slowly to the floor. It is full of slimy brown water. From the expression on everyone's faces it is clear that the contents don't smell very pleasant. MEISIE approaches the bucket, and with her head half-turned she unties the knot. GERTIE presses a handkerchief over her nose. As MEISIE completes untying the rope, it is pulled rapidly upwards, and the trap door then shuts with a bang.*)

Go and empty it out, Meisie. And don't spill any.

CONSTABLE: Let me help you.

MEISIE: Thanks. If it's full, it's very heavy. If you take that side and I take this side…

CONSTABLE: Good idea.

MEISIE: And if we talk a lot, then we don't have to listen to the music.

(*The CONSTABLE stands and MEISIE takes his arm, leading him to the bucket. She puts his hand on the handle.*) It's very nice of you, Constable.

(*MEISIE and the CONSTABLE move with the bucket to the back door. Some of the contents slop out.*

MIEM: Meisie, warn the Constable about the three steps up to the outhouse.

MEISIE: Yes, Ma. (*She opens the door.*)

(*The circus music can be heard. The CONSTABLE and MEISIE exit.*)

MIEM: (*Stepping carefully over the spillage, going to the door and looking out.*) And don't stand on the irises! They're so lovely this year. (*Softly, to GERTIE.*) That little pair is getting along very nicely!

(*GERTIE goes and sits on the chair next to the stove.*)

It's very cold. We could still have frost tonight. (*Short silence.*) That dreadful music. If I just think...! (*She shudders.*) Magicians and half-naked people swinging from ropes.

GERTIE: The whole herd of them were parading around the streets today as well.

MIEM: Did you watch them?

GERTIE: What else could I do? I was just going to cross the street, and there they were.

MIEM: It must have been quite a spectacle!

GERTIE: There were horses with feathers and girls with hardly any clothes on riding them. There were clowns playing very loudly on out of tune trumpets, and a little dwarf with a white face...

MIEM: Oh, stop it! I don't want to hear any more. (*She sighs and shakes her head. She looks out of the door again. Silence.*)

GERTIE: Where are they? Can you see them?

MIEM: (*Almost tenderly.*) Yes. They're under the peach tree. Talking.

GERTIE: (*Quickly rising.*) Let me see! (*Moving to the door.*)

MIEM: Watch out! Some spilled.

(*GERTIE skips over the splash.*)

GERTIE: (*Looking out.*) Why are they whispering? And standing so close together.

MIEM: Nothing wrong with that. He's a nice young man.

GERTIE: He's much too old for her.

MIEM: Oh, come on, Gertie. A few years over twenty.

GERTIE: I'm sorry, Miem but there I'm sure you're wrong. Blind people always look younger.

MIEM: Shh. They'll hear you. Who knows? His ears might be as good as his nose. Gertie! Don't stand in it. (*Looking*

out, dreamily.) If she gets married, he'll come down. He'll have to. He'll be ashamed to have another man give his daughter away.

GERTIE: (*Suddenly shrill.*) Come inside, you two! You'll catch cold!

MIEM: (*Angry.*) Gertie!

(*GERTIE looks a little embarrassed and goes to sit on her chair. MEISIE leads the CONSTABLE in. Her cheeks are glowing and her eyes shine. She closes the back door, and the circus music can no longer be heard.*)

GERTIE: I know your circulation isn't very good, Meisie. She's very sensitive to the cold, Constable. Probably from all the sitting.

MIEM: (*Shouting up to the trap door.*) Let it down!

GERTIE: I teach physical education, Constable. And I really believe in it. (*She jumps up and does a few quick exercises.*) Deep breathing and regular exercise. Look at me. My hands never get cold. Warm all the way down to my toes.

(*The trap door opens and the rope descends.*)

MIEM: (*Irritated.*) Oh, come on, Gertie! (*She ties the bucket to the rope.*) I always say that too much exercise makes a woman scrawny and tough. (*Indicating with her head.*) Meisie, you spilled some. Get a cloth and wipe it up. (*Loudly, upwards.*) Pull it up! And don't wait two days again.

MEISIE: Yes, Ma. (*She gets a cloth and cleans the mess.*)

(*The trap door slams shut. Far away, dogs bark.*)

GERTIE: Listen. Can you hear it? I think it's the police with their dogs. (*She scuttles to the window.*) Yes. Just look. Lots of them, with torches.

(*MIEM joins her at the window. MEISIE throws the cloth into the bucket under the washstand and joins MIEM at the window.*)

MIEM: They're walking down the river.

GERTIE: They must be walking all the way round the village, making sure everything's safe.

MIEM: I don't know…I still feel uneasy. If he really wants to…nothing's going to stop him.

GERTIE: Ag, no man, Miem…

MIEM: Monsters like that are clever as the devil himself.

GERTIE: I'm glad I'm not out there. Or alone in my house. (*She shudders.*)

MIEM: When I think of all those young girls walking home alone from the circus…

(*They both make concerned sounds.*)

Over the fairground, past the cemetery and that abandoned station.

MEISIE: They could take another route.

MIEM: (*Whispering ominously.*) Maybe. Along the river. Through the reeds and the long grass…under the willow trees.

MEISIE: Ma! Please, stop it. I'm getting scared.

MIEM: Don't worry, my girl. There's no need to be frightened. You're safe here. Just like a little bird in its nest.

(*MEISIE sits and resumes her work.*)

GERTIE: (*Still looking out of the window.*) I can't see the lights any more. They've all gone behind the silo. (*The sound of the dogs gets softer and softer, until after ten speeches, it is indiscernible.*)

MIEM: (*Cross.*) Gertie, come away from the window and close the curtain! You never know who's out there peering in at us.

MEISIE: Do you think so, Ma? Do you really think that there is someone out there?

MIEM: Could be. You never know. But don't upset yourself, or you won't sleep well again. I'm sure that you don't have any reason to be afraid. Wagter will warn us of any danger. And of course, there's the Constable.

(*His stick falls. GERTIE picks it up quickly.*)

GERTIE: Here you are, Constable.

CONSTABLE: Thank you, Miss.

GERTIE: Only a pleasure. (*She giggles, and catches sight of MEISIE adding a sack to the heap.*) It's so late for that poor child to be working…she must be exhausted. I think that she should get some sleep. Aren't you tired, Meisie?

MEISIE: Yes, I am.

GERTIE: And your mother's not very well either. She should also get some rest. Why don't the two of you go to bed, Miem. I'll keep the Constable company for a little while.

MIEM: (*Reluctantly.*) Yes, well, it is late. And I have to be up at the crack of dawn to keep an eye on the manure consignments. (*She nods in the direction of the bags.*) Will we see you tomorrow morning, Constable?

CONSTABLE: Sad to say, I have to leave at midnight.

MIEM: Of course. By then the danger should be over. But you must come in and see us if you find yourself in the area again.

CONSTABLE: I will. Thank you for your hospitality.

MIEM: And thank you for your help. We'd never be able to get a wink of sleep without you.

CONSTABLE: Just doing my duty, ma'am.

MIEM: Say goodnight to the Constable, Meisie.

MEISIE: (*Shyly.*) 'Night.

CONSTABLE: Goodnight.

MIEM: Well, we're off then. I hope to see you soon.

CONSTABLE: Goodnight, Mrs Fick.

(*MIEM and MEISIE exit through the passage door.*)

MIEM: Goodnight, my child.

MEISIE: 'Night, Ma.

(*There is the sound of doors shutting offstage. A silence ensues between the CONSTABLE and GERTIE.*)

GERTIE: (*Clearing her throat.*) The church bells haven't rung yet. That must mean that nothing's happened. Everyone will be so relieved tomorrow morning if the curse has been lifted. And it'll all be thanks to our brave police officers. (*Little giggle.*) Like yourself. (*Short silence.*) What about another cup of coffee, Constable?

CONSTABLE: No, thank you. I've had quite enough already.

GERTIE: Something to eat?

CONSTABLE: No thank you, Miss.

(*Short silence.*)

49

GERTIE: Constable, there is something that I'd really like to ask you. I hope that you won't mind.

CONSTABLE: Ask away, Miss.

GERTIE: If it's too…personal, I'll understand completely.

CONSTABLE: What is it that you want to know?

GERTIE: Well, you said that all ladies look alike to you since your…accident. Either like your mother or your aunt.

CONSTABLE: Tant Hannie.

GERTIE: That's right, yes. (*She clears her throat.*) Now, what I want to know is…which one do I look like?

CONSTABLE: Tant Hannie. Definitely.

GERTIE: But how do you make the choice? I mean between your mother and Tant Hannie, if I may call her that?

CONSTABLE: Of course. It's the voice. It all depends on the voice.

GERTIE: Really? How interesting! (*Short silence.*) And could you perhaps tell me just a little about this Tant Hannie?

CONSTABLE: She never got married. She was beautiful, but far too choosy.

GERTIE: Good heavens. We sound very similar. (*Embarrassed laugh.*) And I'm not all that unattractive either. (*Short silence.*) Could you tell me any more?

CONSTABLE: She was well known for her hair. Long, golden, wavy hair.

GERTIE: (*Touching her fine, mousy hair.*) Astonishing! That's exactly how my hair looks.

CONSTABLE: (*Happily.*) Really?

GERTIE: Yes. Just like that. Tell me more, please.

CONSTABLE: She was tall and slim…and supple.

GERTIE: (*Almost shrieking with excitement.*) Just like me! It's all the exercise. It keeps me fit.

CONSTABLE: I used to watch the grown-ups dancing a lot. And could she dance! No one could dance like her!

GERTIE: (*Very excited.*) That's right! (*Leaping up.*) I'm the best dancer in the district!

(*As the CONSTABLE speaks, GERTIE dreamily recreates what he describes.*)

CONSTABLE: In the waltz, she leaned her head back. She had a long, milk-white neck and she kept her eyes half-closed.

(*GERTIE sways back and forth, body bent sharply back as described. Her arms are stretched out in front of her, and her eyes are just open. She has a smile playing about her mouth.*)

(*After a silence.*) And when she danced the polka, her feet moved so nimbly.

(*GERTIE dances a hysterical polka.*)

She'd laugh.

(*GERTIE laughs.*)

And her dress spun out high around her...no man could keep up. That's when she'd break loose and on her own, she'd spin, spin, spin... (*As he says this, GERTIE turns quickly with her arms stretched out at her sides.*)

GERTIE: (*Laughing, out of breath, with a strange, coquettish voice.*) That's right. Men are so clumsy. They can never keep up!

(*Silence. The CONSTABLE sits with a dreamy expression on his face.*)

More. (*Softly, almost pleading.*) More, if you want to.

CONSTABLE: (*Softly.*) When she came to visit, she'd sleep in my room. My brother had to sleep alone because he wet his bed. (*Short silence. He relives the memories.*) When she comes into the room, I shut my eyes tight. She thinks I'm already asleep.

(*GERTIE is listening with rapt attention.*)

I'm lying dead still, with the sheet up to my nose. But I can see through my lashes.

(*Silence.*)

GERTIE: (*Urgently.*) And what do you see?

(*The wind can be heard in the distance.*)

CONSTABLE: She walks past the bed. Softly, on her toes. And lights the lamps. One on the washstand, and one on the dressing table. It's summer. She stands at the open window. The netting blows against her cheek.

(*GERTIE turns her head as if leaning against a post.*)
She stays there for a while, then she goes to the dressing
table and sits down. She lifts her arms, and slowly
loosens her hair.
(*As the CONSTABLE talks, GERTIE loosens her hair. There
is a calm ecstasy on her face. Her movements are slow, almost
like those of a person under hypnosis.*)
Not all at once, slowly, her hair falls slowly over her
shoulders, streaming down her back...until it's all loose.
Long hair...almost touching the floor.
(*GERTIE's thin hair is also loose and stands fine and erect
on her head. She stares in front of her as if into a mirror.*)
Then she folds some hair over a shoulder and starts to
brush. A hundred times.

GERTIE: (*Stroking her hair with one hand. Very softly.*)
One...two...three...four...

CONSTABLE: She stands up. (*Short silence.*) She walks to
the long mirror in the corner. I can see her from behind.
And from the front.
(*GERTIE stands left-front, as if she were looking in a mirror.*)
(*Speaking slowly, rhapsodically.*) She just looks at herself at
first, her fingertips stroking her face.
(*GERTIE strokes her face with her fingertips, smiling
ecstatically.*)
And now she begins to undress. She's in no hurry. She
unbuttons her blouse very slowly.
(*GERTIE begins to unbutton her blouse.*)
From throat to navel. Each button. One by one. She pulls
her blouse over her shoulders and it falls.
(*GERTIE lets her blouse fall to the floor. She is wearing an
unsightly woollen camisole underneath.*)
And she stands there in her underwear. Made of lace
and silk.
(*GERTIE looks at herself joyfully in the imaginary mirror.*)
She's looking at herself again. Stroking her palms slowly
down her sides.
(*GERTIE does this, sighs with pleasure.*)
And she becomes two people. She desires. And she
is desired.

(*GERTIE, almost swooning, stares at her 'reflection'. Suddenly a door opens. The sound of the wind stops. There are footsteps in the passage. GERTIE looks bewildered, as though just woken from a sleep. She grabs her blouse and hairpins from the table, and disappears through the back door. It bangs in the wind behind her. After a moment, MIEM appears in the doorway, carrying a pink blanket.*)

MIEM: And who left in such a hurry?

CONSTABLE: Miss Gertie.

MIEM: (*Snorting.*) Must be the fresh air and exercise again. It's really very thoughtless of her. On a night like this! I'm sure Wagter will keep an eye on her though.

I brought you this blanket. You might like to sleep a little on the couch. Well, goodnight, Constable, and thank you again.

CONSTABLE: Goodnight, ma'am.

(*MIEM suddenly bursts into tears and sinks down onto a chair.*)

CONSTABLE: What is it, ma'am?

MIEM: It's been so long since…since…a man said goodnight to me. (*She cries.*) If only I could see him! Just once! Before one of us dies. (*Looking up, with a shuddering sigh.*) Seven years. I can hardly believe it. Time goes so quickly. (*Wiping her eyes.*) It's his pride you see. The farm's been in the family for generations. And then, along came the Depression and he lost all his land and every pig, sheep and cow. Everything. We had just enough to buy this scrap of land. This hovel. A few days after we moved here he disappeared. We searched high and low, and in the evening we discovered (*Looking up, her voice shaking.*) that he was up there. He locked the attic door behind him and despite all our pleading and begging…we never saw him again. (*She sighs deeply and takes her face in her hands. After a silence she looks up at the CONSTABLE.*) I must admit, Constable, that to see a man here again…at this time of night…well…it wakes up something in me. Yes. Even in a sickly woman of my age. If one is used to…(*She looks upwards again.*) it's very difficult to live like this, without a man.

CONSTABLE: (*Sympathetically.*) I'm sure it is, ma'am.

MIEM: We always went for a walk in the late afternoon. Never spoke much. He held my arm and sucked on his pipe... (*She sighs.*) Ah, well...I'm sure that he'll come down. The day Meisie gets married. I can see it... Gabriel...a little older, but still a handsome man and Meisie with a veil and train. Slowly they walk to the pulpit, slowly, while the organ plays. And there in the front of the church, a young man is waiting. (*Whispering meaningfully.*) A very lucky young man. (*She sighs.*) Well, that's my only hope.

(*The back door opens again, and GERTIE reappears. Her blouse is neatly buttoned, and her hair is somewhat untidily pinned up. The circus music can be heard.*)

Gertie, what on earth are you doing wandering about out there? You know how dangerous it is!

GERTIE: (*A little embarrassed.*) Exercises and cold, fresh air...ensure a good night's rest.

MIEM: And close the door.

GERTIE: Sorry, Miem.

(*The circus music is no longer heard.*)

MIEM: (*Standing up heavily.*) Well, I'd better get to bed.

GERTIE: Me too.

MIEM: I must get up early. They're loading the manure at seven o'clock.

GERTIE: The school bell rings at a quarter to eight.

(*Dogs barking.*)

MIEM: Hear that? That's the police dogs barking.

GERTIE: The town is really well protected. (*Looking shyly at the CONSTABLE.*) I'm sure that nothing will happen this time.

MIEM: I don't know, Gertie. I've got such a...strange feeling. But shoosh. I don't want to be a prophet of doom. Let's go and get some sleep. Constable, hope we see you again soon. (*She turns down both lamps.*) I'm turning down the lamps, Constable. Everything costs money and it's all the same to you, isn't it?

CONSTABLE: That's right, Mrs Fick.

MIEM: Goodnight, Constable.

CONSTABLE: Goodnight, Mrs Fick. Goodnight, Miss.

GERTIE: Goodnight, Constable.

(*GERTIE and MIEM exit through the passage door. The stage is almost dark. The CONSTABLE sits still. A door bangs closed. He remains still for a while longer, and then feels about under his chair for his bag. He picks it up and places it on the table in front of him. Then he looks around quickly in the direction of the passage door. Then he looks at his bag. He opens the bag, plunges his arm into it, and gropes around the bottom of it. With a quick movement he produces a shiny, red apple. He takes a bite and then sits back and chews. After a while, he looks at the back door. He puts the apple down, stands and moves slowly, but without his stick, to the door and opens it. He stands with his back to the audience and listens to the music. He has his face against the screen door and his left hand above his head leaning on the frame. He stands there for several seconds. Then he turns slowly. There is a faint smile on his face. He moves forwards, but keeps the door directly behind him open, so that he is back lit by the moonlight falling through the gauze. He undoes his coat's leather belt buckle. With a sudden movement, he pulls the belt from its loops, and throws it onto a chair. Slowly he unbuttons the coat from top to bottom. After the first few buttons, he turns his head suddenly as though hearing some sound in the house. He takes the coat off. His torso is naked. With quick, flamboyant movements, reminiscent of those of a magician doing an impressive trick, he turns the coat inside out. The two sides are completely different. It is now the jacket of a harlequin or Pierrot, made of shining silk. The black and silver silk forms a diamond pattern, and there is a soft black collar round the neck. He puts the jacket on slowly, with much ceremony. It has no buttons, and hangs open. He listens to the music, and smiles slightly. Then he moves his head from side to side. Dreamily, he executes a few marionette-like dance-steps. He stops when he hears something. He goes quickly to the back door and closes it. He stands, as before with his back to the audience and one hand on the doorframe.*)

MEISIE appears in the passage doorway. She is barefoot and wears her white confirmation dress. She doesn't look at the CONSTABLE.)

MEISIE: *(Head down, shy.)* I heard them go to bed. Then I came. You said I must wear my confirmation dress. *(The CONSTABLE turns and looks at her.)* But it's a bit small. *(Looks up, startled.)* Where's the Constable?

CONSTABLE: It's me. Don't you recognise me?

MEISIE: You look...different.

CONSTABLE: I always look like this at this time of night.

MEISIE: Always?

CONSTABLE: Yes. *(He smiles.)* Always. *(He takes his glasses off slowly and looks at her.)*

MEISIE: And...you can see.

CONSTABLE: That's because it's so late. When it gets very late, I can always see.

MEISIE: Really?

CONSTABLE: Yes. And I'm glad I can see, because now I can see you. And you are beautiful.

MEISIE: *(Amazed.)* Am I?

CONSTABLE: You are.

MEISIE: *(Shyly.)* You said I shouldn't wear shoes.

CONSTABLE: Yes. *(He opens the curtain.)* It's better that way. *(He opens the window. The music can be heard.)*

MEISIE: Please! Close the window! I'm not allowed to hear the music! Please!

CONSTABLE: Just for a while. It lets in the night air.

MEISIE: *(Pressing her hands to her ears.)* It's so loud! I'm not allowed to hear it!
(The CONSTABLE opens the door quickly. The music becomes even louder.)
No! Close the door! *(She running to the door.)*
(The CONSTABLE stops her. She runs to the washstand and leans over it to close the window. He puts his hands about her waist. She freezes. He turns her slowly towards him. Her arms drop. He takes her face between his hands and looks at her. She starts to move her head slowly from side to side.)

(*Slowly, almost as if she were going to sleep.*) Please...close the...window please...close the door.

(*She suddenly breaks away from him. She puts her hands over her ears and stumbles through the room towards the passage door. She stops and slowly turns around and sees the CONSTABLE. He stands dead still and stares at her. The music gets louder. She also stands still. While she stares at him, she slowly removes her hands from her ears. She moves her head in time to the music. Then she begins to do delicate dance steps, like those of a marionette. She dances through the room, the dance becoming more abandoned. She laughs and dances around the table. The CONSTABLE opens the screen door and puts a stone in front of it to stop it. She dances to the back door. Before she dances over the threshold, she stands still and looks at the CONSTABLE. He makes a slight bow and with a charming hand gesture, he shows her out of the room. She dances out of the door. The CONSTABLE watches her for a little while. Then he moves, quick and agile, picks up his stick, folds it up and packs it into his bag along with his belt. He closes the bag, and exits quickly. He slams the screen door behind him. For a second, he turns and looks through the gauze. Then he disappears into the night. The lights dim slowly as the circus music swells, becoming deafening, and plays for some time in the dark.*)

The End.

CROSSING

translated by the author

To Gordon Dickerson with thanks

Characters

HERMIEN
Respectively fifty and thirty years old. Tall
and gaunt with colourless hair. Her appearance
changes during the course of the play and this
will be indicated in the text.

SUSSIE
Respectively fifty and thirty years old. Shorter
than Hermien with a prominent hump. She has
full lips, large eyes, and long hair. Her appearance
changes during the course of the play and this
will be indicated in the text.

MAESTRO
Between forty and fifty years old. A tall man with
dark hair and deep piercing eyes. He has a strong
magnetic presence and a deep seductive voice. He
wears a black tailcoat and black trousers and at the
start of the play a cloak and a top hat.

EZMERELDA
Fragile, doll-like young girl with an abundance of
ringlets tumbling over her shoulders and down her
black. Her eyes are large, her cupid-bow mouth is
red and there are two red patches on her cheeks. She
is wearing an elaborate, light-coloured dress extremely
low-cut. Her dress and her shoes are too big for her.
She wears a string of 'jet' beads. At the start of the
play she wears a travelling cloak with a hood.

The set: the parlour of a large house on the bank of a river in the north of South Africa. It is a generous room. Front left there is a bay window with faded velvet curtains drawn across it. Upstage right a door leads to the bedroom. Upstage left in the back wall an arch leads to the entrance hall. There is a landing in front of this arch and three steps leading down to the parlour. Left, centre stage, an ottoman is angled slightly towards the audience. Middle, centre stage, an upholstered armchair is turned towards the ottoman. Front stage, extreme left, there is a small desk and a chair. On the desk is a paraffin lamp. Right centre, there is a round table covered with a floor-length cloth and a hanging lamp above it. The two chairs at the table have ornately carved backs. On the table there is an oblong tin with a lid. Against the back wall there is a sideboard and above the sideboard hangs an oval portrait of two, nearly identical, pale female faces. On the sideboard are two glasses and a decanter filled with sweet wine. All the exits and entrances to the kitchen, the floor above and the front door, are made through the entrance hall arch. A large grandfather clock can just be glimpsed in the hall. In front of the arch on the landing, there is a marble graveyard angel. The angel is seen from the side with its wings spread behind it.

Period: the play takes place in the early spring of 1930 and 1910.

Effects: the characters should be so pale that their faces appear almost mask-like. Sensitive orchestration of the sound effects is of the utmost importance.

Crossing premiered at the Nico Arena Theatre, Cape Town on 22 October 1995, with the following cast:

HERMIEN, Diane Wilson

SUSSIE, Mary Dreyer

MAESTRO, André Roodtman

EZMERELDA, Jana Botha

Director, Marthinius Basson

Slow fade up. The paraffin lamp above the table as well as the one on the desk are burning. For a few moments only the soft rushing of the river can be heard. HERMIEN is sitting at the desk. She is wearing a dark, late-twenties dress. Her greying hair is confined in a tight bun. There are dark shadows under her eyes and her lips are pale. She is writing with a scratchy pen and seems to be making sums. From time to time strong gusts of wind can be heard in the trees. After a while the bedroom door opens slowly and SUSSIE appears. She is wearing an ankle-length flannel nightgown and a woollen shawl with long fringes. Her greying hair is confined in a tight plait which hangs over one shoulder. There are dark shadows under her eyes and her lips are pale. For a while she is motionless and then she moves slowly, as if in a trance, towards the table. HERMIEN sees her and starts. Then HERMIEN puts down her pen and moves slowly and soundlessly towards SUSSIE. She touches her lightly. SUSSIE starts.

HERMIEN: I thought you were sleep-walking again (*She moves back to the desk.*) What's the matter with you? You look as if you've seen a ghost. (*She writes.*)

SUSSIE: (*Quietly, distracted.*) I had a dream and then I woke up. Now I can't get back to sleep.

HERMIEN: (*Writing.*) It must be the wind in the trees.

SUSSIE: No, it's the dream. I don't quite remember it and yet… I can't seem to forget it.

HERMIEN: (*Writing.*) You mustn't let dreams disturb you. Of course I'm not talking about visions and premonitions. They are an entirely different matter. There! Now our books are in order. (*She shuts the heavy book.*) I do hope I'm not getting a headache. When I work with figures I always get a headache. (*Getting up.*) Maybe some sweet wine will help. You can pour me some if you like.

SUSSIE: (*Moving to the sideboard.*) What about me?

HERMIEN: If you like. But only a little.
(*SUSSIE carefully pours sweet wine into the glasses. She fills the glass for HERMIEN and pours a very small amount for herself. The sound of happy laughter upstairs.*)
Listen. How happy they are!

SUSSIE: (*Taking a small glass of sweet wine to HERMIEN.*) In the bedroom you can hear them very well. They're just above us.

HERMIEN: (*Taking the glass.*) Is that how you spend your time? (*She takes a sip.*) I've always thought as much. That you eavesdrop on our guests and peep through keyholes.

SUSSIE: How else must I see them? (*She licks the last drop of sweet wine out of the bottom of the glass.*)

HERMIEN: Keep your nose out of other people's business and your eyes to yourself.

SUSSIE: (*After a silence.*) Can we look at our mementos? (*Silence.*) Please?

HERMIEN: It's very late. The clock has just struck. It is a quarter to eleven.

SUSSIE: Not many, only three or four.

HERMIEN: (*Smiling.*) Oh, very well then. At least it will take my mind off the figures.
(*HERMIEN and SUSSIE sit at the table.*)

SUSSIE: (*Pushing the tin towards HERMIEN.*) You can start. (*HERMIEN opens the lid and rummages in the tin. She picks out a large round button. SUSSIE stretches out her hand and takes the button. She rubs it between thumb and forefinger. SUSSIE touches all the objects that are taken from the tin with a true sensual delight.*)
Marthinus Johannes.
Blonde, with corduroy trousers.

HERMIEN: His eyes were closed.

SUSSIE: We couldn't open them.

HERMIEN: No, we couldn't.

SUSSIE: (*Looking at the button.*) All the buttons were still on his shirt.

HERMIEN: He was stiff.

SUSSIE: (*Stretching her arms out in front of her.*) With his arms stretched out in front of him.

HERMIEN: (*Satisfied.*) No one ever fetched him.

SUSSIE: Every Sunday in the summer I put flowers on his grave. (*She throws the button back in the tin. She pulls the tin towards her and rummages excitedly. She takes out a pocket-watch on a chain. She swings it gently from side to side.*)

HERMIEN/SUSSIE: (*Together.*) Stoffel Gerhardus!

HERMIEN: (*Clapping her hands together.*) That's quite right. He was almost old. Balding with a grey beard.

SUSSIE: His eyes were wide open and brown.

HERMIEN: But dull.

SUSSIE: (*Looking at the watch.*) His pocket-watch stopped at half-past ten. (*She shakes the watch.*) There's still water inside. (*She holds it next to her ear.*) I can hear the water.

HERMIEN: (*Taking the watch from SUSSIE.*) Now it's my turn.

(*HERMIEN rummages and takes out a leather pouch.*)

SUSSIE: Lukas Stephanus! (*She opens the pouch and shakes it. Two round river stones roll out onto the table.*) We found these river-stones in his pocket. (*She knocks the stones together rhythmically.*) His eyes were open and blue and he was young. The current was so strong it had torn off all his clothes.

HERMIEN: Washed away his shoes. Yes.

SUSSIE: There was a deep cut across his cheek and a wound in his thigh.

HERMIEN: We had him for only one day and then they came: Pa, Ma, all the brothers and sisters. The wailing! A whole choir. (*She puts the stones back into the pouch.*)

SUSSIE: I dried his hair, fair hair that curled around my fingers.

HERMIEN: Yes. I wish we could have kept him. (*She puts pouch back into tin.*) Come on then. One last one.

(*SUSSIE pulls the tin towards her and takes out a long string of 'jet' beads.*)

No! Please! (*She takes the beads from SUSSIE and puts them back into the tin.*) I don't want to remember her. She'd been too long under the water. (*Deep sigh.*) The poor misguided fools. I warn them but they don't listen. Always in a hurry. Too eager. Too greedy.

(*SUSSIE is dreamily pensive and not paying attention to what HERMIEN is saying.*)

And when the river is in full flood they must get through! What more can I do? I can only do my best. Only my best.

SUSSIE: Can you remember the one with the small fish in his pocket? His pocket was filled with water and the little fish was swimming around and around.

HERMIEN: (*Without interest.*) Yes, I remember. (*She shakes her head.*) When we were small all they wanted were river diamonds. Shining under the lamp. Yes, I remember. Stars, the men called them. Stars under water, stars in the sand. Now it's river gold but nothing's changed. Scabby hand, dirt under their nails. They search and sift and weigh on tiny scales. They're consumed by diggers' fever. Now gold and then diamonds but nothing has changed. Now and then, one and the same.

(*A service bell tinkles.*)

(*She jumps up.*) It's them!

SUSSIE: Let me go. Please.

HERMIEN: You!

SUSSIE: Yes, me.

HERMIEN: The poor young couple on their wedding night! Do you want to give them a fright?

SUSSIE: I only wanted to see what they look like. I've only seen you, Ma, dead people, Maestro…

HERMIEN: How many times have I warned you not to mention that name in this house? I'm not warning you again! (*Silence.*) You know you must keep out of sight and not alarm the guests. (*Loudly.*) I'm coming! Oh, before I forget, he wants his tailcoat brushed down. Do it now or you'll forget. (*She takes a tailcoat from the back of the chair and picks up a clothes brush from the seat of the chair. She gives the tailcoat and brush to SUSSIE. SUSSIE takes them reluctantly. HERMIEN exits. SUSSIE starts brushing the jacket. Then, slowly, she brings it towards her face and inhales with sensual pleasure. She rubs her cheeks against the fabric. She starts brushing again, slowly and rhythmically. She bends back and lays the jacket on top of her, folding the arms around her neck. Her eyes are closed. Her brushing becomes more and more rapid. She gives a stifled cry and drops the clothes brush. The sound of approaching footsteps. SUSSIE quickly hangs the coat over*

*the chair. She looks furtively over her shoulder and then
pushes her hands deep into the pockets of the tailcoat.)*
(Entering.) They only wanted me to fetch their plates.
(Looking at the clothes brush.) And what's the brush doing
on the floor?

SUSSIE: *(Quickly takes her hands out of the pockets.)* I dropped
it. Sorry.

HERMIEN: You're so clumsy. Poor thing, what can one
expect? You should see them. *(She sits down slowly.)* How
happy they are! I peered over his shoulder and then
I saw her. Sitting in the chintz chair in front of the fire,
wearing a white nightgown with pink ribbons. Her hair
is long and loose and her eyes are shining. The room
smells of lavender and violets. On the dressing table
there is a silver brush. *(She smiles.)* I'm so glad I could
warn them before they tried to cross the river.

SUSSIE: Perhaps later…he'll brush her hair.

HERMIEN: Yes, perhaps he will.

(Wind howls.)

HERMIEN: Listen. There might be another storm. And the
river is already so full.

SUSSIE: I'm afraid of the wind. Do you remember when
the wind tore the roof off? The whole house groaned and
rocked. All the candles and lamps were blown out and
the rain ran down the walls.

HERMIEN: And the time when all the orange trees in the
orchard were blown over with their roots in the air.
Right up in the air.

SUSSIE: Or when the big black bluegum tree burst
through our window.

HERMIEN: *(Sighing.)* Yes. A storm is coming. We nearly
died of fright that night. You were covered by the leaves.
(Wind howls.)
(She listens.) But even if there's no storm, it'll still blow
green lemons from the trees, break the shutters or smash
birds against the windows. But one thing is for certain,
it's bringing more rain. I could have told you yesterday.
I had pains in all of my joints. Just listen to the wind

rushing through the poplars. (*She moves to the window and opens the curtains.*) Thin cloud covers the moon.
(*SUSSIE moves toward HERMIEN and stands behind her.*)
You mustn't look! Do you want to see your own reflection? (*She firmly closes the curtains.*)

SUSSIE: And why not? The only mirror in the house is very small and cracked and I only see my face in it. (*Pause. HERMIEN looks back at SUSSIE.*)
Am I so monstrous?

HERMIEN: Enough of that. (*She sighs.*) Yes, our heavy task begins again. Tomorrow we must go over the nets and the hooks.

SUSSIE: I'm so tired of lifting heavy wet bodies out of the water. I'm tired of dragging them all the way up the hill. Tired of digging graves. Sometimes it takes two days.

HERMIEN: And why should you complain? The earth is always soft after the rain.

SUSSIE: But there are lots of stones.

HERMIEN: (*Sighing.*) I know. I know it's not easy.

SUSSIE: Why don't we just leave them where they are?

HERMIEN: That is not how our mother brought us up. You know it is...

HERMIEN/SUSSIE: Our sacred duty.
(*HERMIEN stands behind SUSSIE. SUSSIE mouths what HERMIEN is saying as though she knows it by heart.*)

HERMIEN: Surely you know what happens to the poor souls who drown and are never found. Who have to lie for ever and ever in the dark depths of the river among willow roots and crabs. No one knows of them. No! They are utterly lost. They don't get a decent burial (*She indicates towards the window.*) with their Christian names on a cross. They know no rest but wander the earth until the last day! Is that what you want?

SUSSIE: I don't care! I wish I could go away! Far away! Where there's no water. Where there are no corpses!

HERMIEN: And where would that be? The people would point and stare.

SUSSIE: Be quiet! Just be quiet! I don't want to hear any more!

(*SUSSIE moves towards the bedroom door. As she reaches the door there is the sound of ghostly heart-rending sobbing.*)
It's her! She's come back. (*Stifled sob.*) I can't bear it.

HERMIEN: Yes it is. I'd quite forgotten about her. That's because she appears only once every five years. (*She sighs.*) We must do something. She'll disturb the guests. And if they notice anything, tongues will start wagging, you can be sure of that. You know how people are. They would rather cross a drift when there is a flood, then spend a night (*Sarcastically.*) in a haunted house.

SUSSIE: But we've tried three times!

HERMIEN: We must silence her or at least calm her down until the guests are asleep. Did you read the full list of names I gave you last time?

SUSSIE: Yes. Every name.

HERMIEN: Did you read them slowly or did you gabble?

SUSSIE: I read them slowly.

HERMIEN: Did you pronounce them properly?

SUSSIE: Yes, I did!

HERMIEN: There is no need to shout!

SUSSIE: (*Hissing.*) Yes, I did.

HERMIEN: And loud enough? Or did you mumble?

SUSSIE: (*Very quietly.*) Loud enough.

HERMIEN: Then I really cannot understand it. If what you say is true…

SUSSIE: Are you accusing me of lying to you?

HERMIEN: (*Silence while she glares at SUSSIE.*) If what you say is true, then we must think of what else to do. (*Sudden irritation.*) The others are always so relieved to give us their Christian names. To be called to by their full names. Then we put their names on the crosses and there is peace and quiet once and for all. (*Sarcastically.*) But of course there are those who have forgotten their names.
(*More heart-rending sobbing.*)
(*Sarcastically.*) I must say tonight she's particularly sorrowful. (*Quietly.*) It gives me the shivers to think of her. No one would have known her. She'd been under the water for far too long.

71

SUSSIE: (*Whispering.*) Yes, it still gives me nightmares.

HERMIEN: I know. Then you scream in your sleep and wake me up. (*She sighs.*) Oh well, we have to do what our mother taught us. I believe in keeping my nose out of other people's business, but it can't be helped. You need to question her. She might remember something that can be of use.

SUSSIE: But it takes a long time.

HERMIEN: I know! Believe me I know. And it tires me out. For days afterwards I'm not myself. But what else can we do?

SUSSIE: Maybe it won't even work.

HERMIEN: The last time we were very successful. You must remember Pieter Joachim. We buried him under the willow tree in an unmarked grave and of course he came back. Very polite, do you remember? He couldn't remember his name either. Five times he manifested and each time it was the same. But when you questioned him he spoke of the storm and of the flood and of the river he tried to cross. And just before the water closed over his head, he saw a vision of his dear mother calling to him: 'Pieter Joachim! Pieter Joachim!' (*Matter of fact.*) Then we put his name on his cross and we never heard from him again. But remember, her full name. Nothing less will do.

SUSSIE: I know. I know.

HERMIEN: And be very careful not to scare her. Don't let her see you from the side.

SUSSIE: (*Tearful.*) Why must I do everything?

HERMIEN: And what about me? Do you think it's easy for me? My gift is a heavy and terrible burden but I inherited the gift and there is nothing we can do.

SUSSIE: Yes, you inherited everything. Mother's gift, her house, her pearls. And I only got a trunk of clothes I can't wear.

HERMIEN: That's only because they won't fit over your back! You can hardly blame our mother for that.

SUSSIE: She never liked me.

HERMIEN: You only imagined it. But this is not the time. Come on, we have work to do. It is getting late.

SUSSIE: Why did I have to stay in the bedroom when there were guests? She came to fetch you, with your hair braided and your best dress and locked the door behind her.

HERMIEN: How should I know? It happened such a long time ago.

SUSSIE: And why could only you go to school?

HERMIEN: I used to teach you everything I learned.

SUSSIE: Why could you go and play with little friends but I never could?

HERMIEN: I was your little friend. You didn't need anyone else.

SUSSIE: It's because of the way I look! I know it! As if it's my fault. But I know whose fault it really is!

HERMIEN: Please. Not that again.

SUSSIE: Yours! Yes, yours! When we were together in our mother's womb, you stabbed me with your big sharp bones. You crushed me with your long thin feet. My soft, tender bones were mangled and bruised.

HERMIEN: I've told you I don't want to hear it again!

SUSSIE: Because it's the truth! And you know it! (*She cries and puts her hair in front of her mouth.*)

HERMIEN: (*Getting up and sitting next to SUSSIE on the ottoman. She strokes her hair tenderly.*) There now! I've always been good to you, haven't I? I make gooseberry jam and I stroke your hump when it aches.

SUSSIE: It's only that it's always been... Hermien this, and Hermien that... But no one has ever heard of me. No one has even seen me.

HERMIEN: Believe me, that is all for the best. But we are happy together, aren't we? Like our mother and Tante Katie?

SUSSIE: (*Soft. Desperate.*) Yes. Yes. Just like our mother...and Tante Katie.

HERMIEN: (*Tenderly stroking her hump.*) There...there...that's better. All over now. We've always slept together in one bed and one day, like them we'll lie

side by side for ever and ever. (*She gestures towards the marble angel.*) With the same gravestone at our head. That is why I told him to make two. One for our mother and Tante Katie and one for me and you. So you see, there's no need to cry Sussie. (*She dries SUSSIE's tears with a small, white handkerchief that she takes from her sleeve.*) I'll always look after you. Yes, always. That's better. No more tears. Come along now, we have work to do.

SUSSIE: I'm tired. I want to go to sleep.

(*Heart-rendering sobbing.*)

HERMIEN: And I have aches and pains. I know it's very late. (*She sighs and shakes her head.*) But of course they have no sense of time. None at all. Come on. We only need her name and then we can get some rest.

SUSSIE: Yes. She frightens me. I hope this will be the last time.

(*HERMIEN moves to the desk and blows out the lamp. SUSSIE moves to the table, climbs on a chair with difficulty and turns down the lamp above the table.*)

HERMIEN: Not too much. (*She moves towards the table.*) At least there are no rowdy diggers tonight. But we mustn't waste any time. If it starts raining, they'll stumble in here, wet and bedraggled, demanding strong spirits of one kind or another.

(*SUSSIE gets off the chair, then takes the two small glasses back to the sideboard and places them on the tray as before.*) *She sits down slowly. She sighs and drops her head in her hands. Sudden gust of wind. She looks up.*) Hurry up! We must begin.

(*SUSSIE sits at the table with HERMIEN. The rest of the stage is now in darkness and there is only a circle of light on the table. During the 'seance' scene, the howling wind becomes more noticeable.*)

I really hope they don't ring the bell. And please, if you want to cough or sneeze, clamp your hand over your nose and mouth.

SUSSIE: I know.

HERMIEN: And if you want to…go you'd better do it now.

SUSSIE: No, I don't want to.

HERMIEN: Very well then, let us begin. (*The clock strikes.*) Wait. Let the clock strike first.

(*They sit motionless while the clock strikes eleven.*)

Well then…

(*HERMIEN stares straight ahead. She puts her arms on the table with her palms facing upwards. After a few moments her eyes close. They flicker. She starts breathing slowly and deeply and does this for quite some time. Slowly she opens her eyes. Now HERMIEN is EZMERELDA. It is a complete transformation. HERMIEN/EZMERELDA is nervous and tentative. Her voice is rather high and childish. She looks around with fear and uncertainty.*)

SUSSIE: (*Quietly.*) Don't be afraid.

HERMIEN: (*As EZMERELDA.*) Did you wake me up?

SUSSIE: Were you asleep?

HERMIEN: (*As EZMERELDA.*) Yes. And…I was dreaming.

SUSSIE: What were you dreaming?

HERMIEN: (*As EZMERELDA.*) I dreamt that I was flying in a swarm of big black birds. Their wings beat the air and they flew around and around. (*Silence. Intertwines her fingers and looks down at her hands. Softly.*) I'm glad I've woken up.

SUSSIE: Could you…perhaps tell me…who you are?

HERMIEN: (*As EZMERELDA. Scared.*) Who…I am?

SUSSIE: What your name is?

HERMIEN: (*As EZMERELDA.*) My name…my name…

(*Drops her head, starts crying softly.*)

SUSSIE: It doesn't matter.

HERMIEN: (*As EZMERELDA. Crying.*) I can't remember. I can't remember.

SUSSIE: Don't cry.

HERMIEN: (*As EZMERELDA.*) I'm cold. (*She shivers.*) So very cold.

(*SUSSIE gets up, takes off her shawl, moves to HERMIEN and gently puts the shawl around her shoulders.*)

(*As EZMERELDA.*) Thank you.

SUSSIE: (*Sitting again.*) Tell me if you can remember anything. Think carefully.

HERMIEN: (*As EZMERELDA. She shakes her head.*)
Everything seems so…far away. I can only remember
my dream.

SUSSIE: (*Gentle and encouraging.*) Think. Think back.
Maybe you'll remember what happened…just before you
went to sleep.

HERMIEN: (*As EZMERELDA. She lifts her head and moves
her head from side to side.*) I don't remember anything,
I really don't. (*She freezes and looks at the lamp above the
table with wonder. Slowly she looks down at the table and
touches the tablecloth.*) But I remember this lamp…
I remember this tablecloth…I think…I've eaten at
this table.

SUSSIE: But are you sure?

HERMIEN: (*As EZMERELDA. Happy.*) Yes! I remember!
(*Frightened.*) Who's that crying outside?

SUSSIE: No one. Only the wind.

HERMIEN: (*As EZMERELDA.*) Yes. I remember the wind.

SUSSIE: You were busy telling me how you had a meal at
this table.

HERMIEN: (*As EZMERELDA.*) And somewhere… (*She
looks up.*) up there…people were talking and singing.

SUSSIE: It must have been the diggers.

HERMIEN: (*As EZMERELDA.*) And you were here! Yes!
(*Very happy.*) I know you!

SUSSIE: Me!

HERMIEN: (*As EZMERELDA.*) You looked almost the
same. (*She looks around.*) And…there were two other
people in the room. A man and a woman.

SUSSIE: What did the woman look like?

HERMIEN: (*As EZMERELDA.*) She was bony and ugly.

SUSSIE: My sister! Hermien.

HERMIEN: (*As EZMERELDA. Frightened.*) What's that?

SUSSIE: I've told you. It's the wind.

HERMIEN: (*As EZMERELDA.*) No, it's something else.
Something that frightens me.

SUSSIE: You must be hearing the river. The water washing
over the stones.

HERMIEN: (*As EZMERELDA. Softly.*) Cold…deep…dark water. (*She gives a cry.*)

SUSSIE: But don't be afraid. You're in here with me, you're safe.

HERMIEN: (*As EZMERELDA.*) Yes. I'm here with you.

SUSSIE: (*Visibly agitated.*) Now tell me…about the man. You said there was a man.

HERMIEN: (*As EZMERELDA.*) Yes. (*She lifts her head as if she can see him.*)

SUSSIE: (*Urgently.*) What does he look like? Tell me!

HERMIEN: (*As EZMERELDA.*) He's tall. I have to look up at him. He wears a cloak and a high black hat. His hair is dark and wet…his eyes…are deep… (*A heartfelt cry. Rising from her chair.*) I'm here Maestro!
(*Sharp intake of breath from SUSSIE.*)
(*As EZMERELDA.*) I'm here! (*She looks sad. She sits down and turns her head away.*)

SUSSIE: Yes…Yes…Maestro…I've never forgotten him…he's the only man I've seen…Maestro…then you must be…what is it again…a strange name…Espranza! No, that's wrong. It was something else. Now I know!

SUSSIE/HERMIEN: Ezmerelda!

SUSSIE: And you're Ezmerelda. I'm so sorry that I didn't recognise you.

HERMIEN: (*As EZMERELDA. Sad. Her head dropping.*) But…it's not my real name.

SUSSIE: Never mind. Everything will turn out well in the end, you'll see. Think again. Think back. Try to remember.

HERMIEN: (*As EZMERELDA.*) I can't remember… anything. (*She weeps.*)

SUSSIE: You must try. Just close your eyes…and think back.

HERMIEN: (*As EZMERELDA. Closing her eyes.*) Yes… I remember now… (*As though she is living what she describes.*) A carriage with two horses… I'm sitting close to him with my head on his shoulder. The night is very very dark. The coach rocks from side to side in the rain

in the howling wind. We stop next to the road and wait for the storm to pass. Everything shakes and trembles. There is light and then darkness. Light and then darkness. Maestro gets out to look at the horses. I'm afraid in the coach. When he comes back, his hair is wet and water runs down his throat. The rumbling gets louder. The whole coach creaks and rattles. I cry and he holds me close. I put my arms around his neck and press my head against his chest. I can feel his heart beating but I can't hear it. He rocks me and kisses me on my eyelids. First on the one…then on the other. The rain grows softer. The thunder moves farther away. We drive on but it's uphill and the mud is thick. We see a light on the hill and a sign. Maestro shouts to the coachman to stop. He gets out and holds a lantern in front of the sign. He reads it out: 'Beware! Do not cross when the river is in flood. Find refuge here. Bed and board.'

SUSSIE: Our sign.

HERMIEN: (*As EZMERELDA.*) Then Maestro says that we must stop there for a bit and we drive through a big iron gate.

SUSSIE: Our gate.

HERMIEN: (*As EZMERELDA.*) We drive down a narrow road and stop in front of a house. The house is dark, but not quite. Somewhere, right up there, we see a light!

SUSSIE: I remember the diggers gambled all night. I remember everything.

HERMIEN: (*As EZMERELDA.*) We get out. My shoes sink into the mud. My train is heavy and wet. Maestro tells the coachman to mind the horses. He lifts me in his arms and carries me to the steps. He kicks against the door and cries: 'Open the door!'

HERMIEN/VOICE OF MAESTRO: Open the door!

(*The lights fade out. In the darkness the sound can be heard of someone kicking against a heavy door. The sound is loud and resounding. The sound of the wind is slowly faded out. The sound of the river grows slightly louder.*)

MAESTRO: (*In the darkness. Off.*) Open the door!
(*For a moment the stage is illuminated by a flash of lightning. As the lights come up, MAESTRO enters with EZMERELDA in his arms. He is carrying a lantern.*)
Is there anyone here? Please answer! Is anyone here?
(*The sound of muted thunder.*)

EZMERELDA: (*Snivelling.*) Not a living soul!

HERMIEN: (*Calling from the bedroom.*) Please wait! I will be with you presently!
(*MAESTRO carries EZMERELDA to the ottoman, bends forward as if wanting to put her down gently, then suddenly drops her.*)

EZMERELDA: Oh! You've hurt me! (*Tearful.*) Why did you do that?

MAESTRO: (*Taking off his cloak and draping it over a chair.*) You are heavy and I am tired. (*He hangs his hat on the angel's head.*)

EZMERELDA: I think something is broken. (*She moans.*)

MAESTRO: (*Lifting the lantern which throws light patterns over the floor and against the walls.*) Not a bad place.

EZMERELDA: Maybe it's my back. Maybe my back's broken.

MAESTRO: (*Putting down the lantern and crossing to the ottoman.*) Then you will have to be carried around like a rag doll. (*He bends over her. He strokes her arms. Softly, with his face near hers.*) I would have to do everything for you. Dress you…and undress you. Wash you…and put you to bed. (*He puts his hands under her dress.*) Can you…
feel that?

EZMERELDA: Yes.

MAESTRO: (*Moving his hand further up her legs.*) And…that?

EZMERELDA: Yes.

MAESTRO: Are you sure?

EZMERELDA: Oh yes.

MAESTRO: (*Getting up quickly.*) Then it can hardly be serious. (*He moves to the window and looks out.*)

EZMERELDA: You said you would be gentle. You said.

MAESTRO: Did I?

EZMERELDA: Yes. And you promised.

MAESTRO: It must have slipped my mind.

EZMERELDA: You promised. (*She cries.*) You know you did.
 (*MAESTRO moves quickly to the ottoman. He sits and holds
 EZMERELDA.*
 The room is illuminated by lightning.)
 (*Her head against his chest.*) I'm so cold. And hungry.
 (*MAESTRO plays with her hair.*)

EZMERELDA: (*Whining.*) I said I was cold and hungry.
 (*Sniffs.*)

MAESTRO: (*Grabbing her hair and pulling her head back.*)
 What did I tell you?
 (*Muted thunder.*)

EZMERELDA: I...can't remember.

MAESTRO: I told you to stop whining and snivelling.
 That is what I said, is it not?

EZMERELDA: Yes yes...

MAESTRO: Never mind. (*He kisses her neck.*) In a short
 while we will be there. I will carry you up the stairs.
 Candles will burn in the bedroom and I will lay you
 down. With your hair spread over the pillow. And
 then...I will tell you all my secrets.

EZMERELDA: Yes. Oh yes. (*She embraces him.*)
 (*HERMIEN enters. Her hair is no longer grey and she is
 wearing a plain Victorian dress with a train.*)

HERMIEN: (*At the bedroom door. Clearing her throat.*) I'm
 glad to be able to give you refuge on such a night,
 Meneer. You did close the door behind you? The wind
 blows leaves and pods into the house.

MAESTRO: I did, kind lady. I am so sorry that we took the
 liberty of entering uninvited, but I did knock.

HERMIEN: Well, you are lucky, Meneer. (*She lights the
 lamp on the desk.*) Earlier this evening a strong gust of
 wind broke the lock. If you hadn't come in, I might
 never have heard you.

MAESTRO: I am deeply sorry that we have to disturb you
 at the dead of night.

HERMIEN: Not at all, not at all. I am grateful that you're
 safe. I only hope you didn't cross the river. (*She moves to
 the table.*)

MAESTRO: No, dear lady. We came from the west. (*He blows out his lantern.*)

HERMIEN: You must be wet and cold, Meneer. (*She stands on a chair and lights the lamp above the table.*)

MAESTRO: Food and wine! That will make us feel much better.

HERMIEN: Of course. (*She gets off the chair. She moves to the sideboard.*) There is still some roast chicken and half a bottle of wine. (*She puts the matches in the drawer and closes it.*) I'll stoke the coals and your food will soon be hot. (*MAESTRO bows formally. HERMIEN exits to the kitchen.*)

MAESTRO: (*Commandingly.*) Take off your cloak. (*He helps EZMERELDA to take off her cloak. He takes her hands and rubs them between his own.*) Like two frozen little birds.

EZMERELDA: (*Frightened.*) What's that? That terrible rushing sound!

MAESTRO: Only the river coming down.

EZMERELDA: I've always been afraid of water.

MAESTRO: There's nothing to be afraid of. (*He holds her.*) Don't I always take care of you? (*He caresses her face with his lips.*)

HERMIEN: (*Off.*) Luckily the oven is still warm. (*She appears in the arch carrying a tray. She clears her throat. There is half a bottle of wine and two glasses on the tray. She puts the wine and the glasses on the table and the tray on the sideboard.*)

MAESTRO: How splendid. Let me pour. Will you partake?

HERMIEN: No. It is much too late for me, Meneer.
(*The room is illuminated by faint lightning.*)
I hope this storm has passed. It was terrible while it lasted. And an owl was blown against the window.

MAESTRO: (*Pouring two glasses of wine and giving one to EZMERELDA.*) Drink this down and it will make you feel warm.
(*The bedroom door opens. SUSSIE stands in the door. She is wearing a long white nightgown and an embroidered Victorian shawl with a long silk fringe. Her long hair is loose. The shadows under her eyes are gone and her full lips are red.*)

SUSSIE: I...heard voices.

HERMIEN: (*Quickly crossing to SUSSIE. Hissing.*) Can't you see? We have guests!

SUSSIE: You're hurting me!

MAESTRO: I am so sorry. Did we wake you up?

HERMIEN: My sister's had a bad dream. She's going back to sleep.

SUSSIE: I don't want to sleep any more.

HERMIEN: I told you! We have guests.

MAESTRO: But the lady is most welcome in our midst. The more the merrier.

HERMIEN: It's very good of you I'm sure, Meneer. But my sister needs her sleep.

MAESTRO: What a pity.

SUSSIE: She's lying! My sister doesn't want anyone to see me. That's the truth!

HERMIEN: What nonsense!

MAESTRO: And why would that be?

(*SUSSIE moves forward. She stops. She turns slowly to the side. She takes off her shawl. Her hump is grotesquely visible under her white nightgown. She turns her face away. HERMIEN gives a soft cry and clamps her hand over her mouth. MAESTRO looks without saying anything. SUSSIE slowly turns her head and looks at him.*

He carefully moves towards SUSSIE. He puts his hand out gently and touches the hump. SUSSIE pulls away.)

But...didn't you know?

SUSSIE: Know what?

MAESTRO: That you have wings in there?

SUSSIE: Wings?

MAESTRO: Yes. Wings. But very tightly folded. Perhaps one day soon they will burst through the hard cocoon of flesh and bone. And then you will spread your wings. Large rushing wings with feathers of many colours.

HERMIEN: That is a very pretty little story, Meneer. But my sister's not a child any more. She knows she is deformed.

(*SUSSIE drops her head.*)

MAESTRO: (*To SUSSIE.*) It is your choice. If you do not wish to believe me... (*He shrugs.*)

(*SUSSIE looks at MAESTRO. For a moment there is an intense contact between them.*)

(*He half stumbles. Then he sits down. Suddenly very tired.*)

I...am really very hungry.

HERMIEN: The food must be ready, Meneer. Sussie, seeing you're up, go and fetch the food for the guests.

(*SUSSIE looks reluctant and moves towards the kitchen.*)

(*She sits.*) You must be very tired, Meneer?

MAESTRO: Oh dear lady, we are. We have been travelling all day.

EZMERELDA: We've been travelling all year! (*Tearful.*) We've been travelling for many years!

HERMIEN: And where are you going, Meneer?

MAESTRO: To the diggings on the river bank a little way upstream.

HERMIEN: So you were going to cross the river?

MAESTRO: That is so. Apparently the crossing is not far from here.

(*Muted thunder.*)

HERMIEN: Yes. Right in front of the house at the bottom of the hill.

MAESTRO: How fortunate.

HERMIEN: Even if the early rains have upset your plans, don't be despondent. I have a nice room for you with a good view of the river.

MAESTRO: Thank you very much, but we will only stay for a short while. We are expected.

HERMIEN: But, Meneer, you dare not! The river is in full flood. Surely you can hear it!

(*SUSSIE enters with a fully laden tray. She puts the food on the sideboard and proceeds to lay the table.*)

MAESTRO: There is nothing to fear.

(*The clock strikes a quarter past eleven.*)

HERMIEN: That's what they all say, Meneer! Listen to me! You'd be in mortal danger! Tell him Sussie!

SUSSIE: Yes it's true.

HERMIEN: There are rapids and cross-currents and whirlpools to suck you under.

EZMERELDA: I'm scared.

MAESTRO: You have nothing to fear.

HERMIEN: Listen to the rushing water! Listen to the stones rolling on the river bed!

EZMERELDA: I'm scared. I'm scared.

MAESTRO: Be quiet!

HERMIEN: You're a fool just like all the rest.

MAESTRO: (*Suddenly friendly.*) Enough of this unpleasantness. I can see the food is on the table.

(*HERMIEN sighs. MAESTRO leads EZMERELDA to the table. EZMERELDA sits where HERMIEN/EZMERELDA sat during the 'seance' scene. SUSSIE dishes up. She is shy and, from time to time, she glances furtively at MAESTRO.*) It looks delicious. You can fill my plate. (*He laughs.*) I'm as hungry as a wolf. But not too much for her. She eats very little.

HERMIEN: You say you are on your way to the diggings. If I may say so, Meneer, you hardly look like a typical gold prospector.

MAESTRO: That is quite true. (*To SUSSIE, who puts a plate in front of him.*) Thank you. I am no prospector. (*He pushes the end of his serviette into his collar.*) Ladies, what an oversight. (*He gets up.*) Let me introduce myself. I am Maestro, the celebrated hypnotist. (*He bows formally and sits.*) I practice the art of hypnosis. (*He starts eating.*)

HERMIEN: (*Very formal.*) I am Juffrou Brand and this is my sister.

MAESTRO: (*Getting up again and bowing formally.*) I am pleased to make your acquaintance.

SUSSIE: I am Sussie. (*She looks at him furtively and puts a plate in front of EZMERELDA.*).

HERMIEN: And I suppose this is Mevrou Maestro?

MAESTRO: Oh no. This is my assistant, Ezmerelda.

HERMIEN: And you travel alone together?

MAESTRO: Not quite. Don't forget my coachman. (*He opens EZMERELDA's serviette and pushes the end of the serviette down the front of her low-cut dress.*)

HERMIEN: Come on, Sussie! (*She indicates that SUSSIE should join her on the ottoman.*)

(*SUSSIE sits next to HERMIEN. They both fold their hands on their lap and they watch as MAESTRO eats voraciously while EZMERELDA pecks at her food.*)
Excuse me. I don't quite understand, Meneer. What is it exactly that you do? What is this… (*She looks inquiringly at SUSSIE who whispers in her ear.*) …hypnosis?

MAESTRO: Dear lady, a strong force flows through me. I am only the instrument. But I am a very particular kind of hypnotist. I make all dreams come true. (*He continues to eat voraciously.*)

SUSSIE: Are you a magician?

MAESTRO: A magician! (*He laughs.*) How amusing. As I said, I make dreams come true and that is why we travel from diggings to diggings. Everyone there searches so feverishly and few find what they are looking for. But for a small fee (*He smiles and wipes his mouth.*) their dreams can come true. (*He jumps up and moves to the landing. Elaborate gesture.*) Usually the small hall is filled to capacity. (*He pauses dramatically.*)
(*Far-off sound of an accordion being played upstairs and a sad song being sung by the diggers. For a while everyone listens.*)
(*After a silence, irritably and loudly.*) Usually the small hall is filled to capacity. My entertainment is extremely popular. I call someone to come forward.
(*MAESTRO takes out his pocket-watch and quickly moves down to the ottoman. He stands behind SUSSIE and swings the pocket-watch slowly from side to side in front of her, while she watches wide-eyed. SUSSIE turns her head away. MAESTRO returns to the landing. EZMERELDA sees the memento tin on the table and picks it up.*)
When they are hypnotised I say: 'Stroll a little way down the river. See how the sun shines on the water. Now take up your pan and get to work. Today may be your lucky day.'
(*EZMERELDA opens the tin and takes out a button.*)

HERMIEN: (*Jumping up.*) Put it back at once! (*She goes quickly to the table, closes the box and then puts it on the desk.*)

MAESTRO: She meant no harm! Look how upset she is. She is very sensitive you know.

HERMIEN: These are our most treasured possessions. Our mementos, Meneer.

(*HERMIEN sits down on the ottoman again. EZMERELDA wipes away her tears.*)

MAESTRO: (*Very irritated.*) Now where was I? Where was I?

EZMERELDA: (*Tearful, prompting.*) This may be your lucky day...

MAESTRO: Oh yes! This may be your lucky day. Then he starts shovelling dirt.

HERMIEN: And where do you find the dirt, Meneer? Do you provide it?

MAESTRO: It is not really there, dear lady. They can see whatever I tell them to see.

HERMIEN: Goodness me.

MAESTRO: And they sift and feel among the small stones. Then I say: 'Look! A nugget as big as an egg.' Then – and it differs from person to person – they start laughing and screaming or dancing and some run around in circles. (*Triumphant gesture.*) And so I give to each who pay the fulfilment of a dream!

HERMIEN: (*Covertly glancing at SUSSIE.*) How interesting I'm sure. And what does your assistant do?

MAESTRO: (*Sitting down at the table.*) The poor diggers see so few fine ladies. And she is always a feast for the eye. Oh yes, she is a great draw card. She has a trunk filled with beautiful clothes. Tell them, Ezmerelda. Tell them about your clothes.

EZMERELDA: I don't want to.

MAESTRO: Come on!

EZMERELDA: (*As if reciting.*) There are lots of lovely things. Hats with feathers and bows. Lace parasols. Dresses made of silk and velvet. White, lavender and rose. Pretty shoes, everything to choose from... (*She turns her head away.*)

HERMIEN: What's wrong?

MAESTRO: Go on!

EZMERELDA: But they're not my clothes. They belong to Ezmerelda.

HERMIEN: What do you mean?

EZMERELDA: All the Ezmereldas before me. They wore these clothes too. I see their stains on the dresses and I smell the sweat under the arms and their musty underclothes. The nightgowns smell of their bodies.

MAESTRO: (*Laughing.*) It's not as bad as that.

EZMERELDA: The shoes are too big for me. (*She gets up and illustrates.*) Look. The sleeves are too wide and I keep tripping over the train. (*She stumbles and falls to the ground.*)

(*The diggers stop playing and singing.*)

MAESTRO: Too big is surely better than too small? (*Getting up and stretching.*) And now I would like to sit back in that easy chair if I may.

HERMIEN: If you like.

(*MAESTRO takes one of the chairs from the table and turns it around. He takes EZMERELDA by the wrist and wrenches her up from the floor. He pushes her onto the chair. He lifts her head and arranges her hands in her lap. She looks wide-eyed and dazed. He sits down luxuriously in the easy chair.*)

MAESTRO: And of course she takes part in the entertainment. The Ezmerelda section of the entertainment is extremely popular. It usually comes at the end and everybody stays for that. She looks breathtakingly lovely and when she appears on stage the crowd cheers. Her cheeks and lips are red and she wears one of her loveliest dresses and feathers in her hair. I take her hand and she makes a small bow and smiles. (*He bows and smiles with a gentle feminine grace. He is not imitating EZMERELDA but seems rather to be embodying her.*) Everyone whistles and claps. Then she lies down and I hypnotise her. It has become very easy for me to hypnotise her. I only have to click my fingers. (*He clicks his fingers.*)

(*EZMERELDA's eyes close. Her head drops and she breathes deeply.*)

As you can see. (*He clicks his fingers again.*)
(*EZMERELDA wakes up and looks startled.*)
And then I say: 'You are getting young and younger. You
are sixteen, you are ten, you are five, you are three.' Yes,
that is where I usually stop. You should see her. She is
quite adorable. She giggles and lisps and sucks
her thumb.
(*HERMIEN is clearly shocked.*)
I usually choose a few who are fortunate enough to play
with her.

HERMIEN: What on earth do you mean?

EZMERELDA: Please! Please! Don't say any more!

MAESTRO: Well, let me see now. They stroke her hair,
tickle her under her chin, pinch her cheek, put her on
their laps and throw her into the air. That makes her
squeal with delight.

HERMIEN: But this is surely no life for an innocent
young girl.
(*EZMERELDA is sitting with her hands over her eyes.*)
(*Sympathetically.*) How did it happen, you poor child?
How were you beguiled into becoming an assistant to
this man?

EZMERELDA: I...can't remember.

MAESTRO: What she means is that she does not wish to
remember. (*He laughs.*) I don't suppose you have more
wine dear lady?

HERMIEN: (*Coolly.*) Unfortunately not.

MAESTRO: Unfortunate indeed.
(*The sound of raucous laughter upstairs. Everybody looks up
and listens.*)
(*After a few moments he leans forward. Confidentially.*) It
was an early spring evening the same as this one. There
was also a storm. (*Dramatically.*) I see a small flickering
light through the lashing rain. I follow a narrow winding
road. I stop in front of a desolate little hovel.

EZMERELDA: No! You promised! (*She flings herself at him.*)
You said you would never tell it again! Never ever again!

MAESTRO: (*Grabbing her wrists.*) Come on. It will amuse
the ladies! (*He flings her down onto the floor next to his*

chair.) I knock and a fat slut opens the door. At first she is suspicious but I give her a pound and she invites me in. The hovel is dingy and the chimney smokes. The fat slut calls to her daughter to make me some food. (*He looks at EZMERELDA. Softly.*) Her daughter comes in. She wears a shawl over her nightgown. When I finish eating the fat slut sends her daughter to bed. Then she makes me a feather bed in front of the fire and also goes to bed. (*He plays with EZMERELDA's hair.*) I wait a little while and then I slowly open the daughter's door. The fat slut is snoring in the next room. The girl is lying on a narrow bed in front of the window.

(*HERMIEN is clearly shocked. SUSSIE sits motionless, her eyes riveted on MAESTRO.*)

Stealthily I move closer. I put my candle next to her bed and I look at her. (*His head droops onto his hand with gentle feminine grace.*) Her cheek rests on her palm and her other hand lies on her breast. (*He places his hand on his breast, his eyes closed. His lips part slightly. He seems to be asleep. He does not imitate EZMERELDA but seems to embody her. He opens his eyes, suddenly.*) I lift the threadbare blanket and get into the bed next to her.

HERMIEN: (*Jumping up.*) That is enough!

(*MAESTRO glares at her and she sits down as though she has no volition of her own.*)

MAESTRO: A cold breeze blows her hair against my cheek and outside the long grass sighs like the sea. I undo her buttons and caress the pale crescent of her breast. I touch the small hollows of her back. She sighs and turns her head. Her lips are slightly parted and the candlelight washes into her mouth. I put my finger lightly between her lips. They are warm and swollen. I feel the wet soft tip of her tongue. I kiss her on her eyelids, first one, then the other. I brush her temples with my mouth. (*Softly with his mouth against EZMERELDA's temple.*) I whisper. I whisper...and she dreams. (*EZMERELDA draws her breath in sharply. MAESTRO laughs, then strokes her arms.*) And she dreams. What does she dream? (*He lifts her hair and kisses her in the nape of the neck.*) What...does...she...dream?

EZMERELDA: I can't remember. Please...I can't remember...

MAESTRO: Yes you can. (*Seductively, with his lips against her hair.*) What are you dreaming? (*Slowly.*) What...are you dreaming?

EZMERELDA: (*Rather automatically with staring eyes.*) I dream that I wake up. I turn my head and I see him next to me. His eyes are half-closed, glinting under his lids. I sit up and bend over him. He lifts his head and flickers his tongue... (*Slowly she touches the hollow in her neck with her forefinger. She falters, drops her head.*)

MAESTRO: (*Kneeling behind her, grabbing her by her shoulders, prompting.*) 'My head feels heavy...'

MAESTRO/EZMERELDA: (*Together.*) My head drops against his chest. I am afraid and I hide my face in the pillow. When I look again he is standing at the foot of the bed. He puts his hands under the sheet. Under my nightgown. He strokes my thighs. He pulls me towards him with my arms above my head. My arms feel heavy. My head falls back.

(*EZMERELDA seems slightly confused as though she had just woken up.*)

HERMIEN: (*Getting up.*) It's late. I think we need some sleep.

MAESTRO: And I knew you were dreaming. Your eyelids flickered and you moaned. I knew you would remember the dream.

EZMERELDA: Yes, I did. When I woke up I remembered. (*She gets up.*) And I was...ashamed.

MAESTRO: That's a lie. (*He lunges at her.*)
(*HERMIEN gets a fright and sits down. After a while she gets up again.*)

MAESTRO: (*Catching EZMERELDA and pulling her down onto the ground.*) When you remembered the dream that was not shame. The hot blood scorched through your veins.

HERMIEN: Stop this! Stop this at once!

MAESTRO: (*With extreme violence.*) I am sick and tired of your lies!!

(*HERMIEN gets a fright and sits down.*)

(*Bitterly, laughing.*) Of course you believe everything she says. But I want you to listen carefully. We will get to the bottom of this. For the rest of the night I slept in front of the fire. When she saw me early the next morning she blushed. I'm right, am I not? When she bent over the hot stove I kissed the nape of her neck. Did she cry out? Did she slap me? No. She trembled lightly and sighed.

(*EZMERELDA drops her head.*)

Why so quiet, dear heart? After that I knew it was decided. When I offered the fat slut sixteen pounds for her daughter's services she accepted it gladly. And the daughter? Did she wail? Did she beg? No! She never even demurred but climbed into my coach without a word. Am I right? And what do you have to say for yourself?

(*EZMERELDA bites his hand. He roars with pain. She writhes out from under him and jumps up.*)

EZMERELDA: I wish I'd never seen you!

MAESTRO: Is that so?

EZMERELDA: I wish I'd stayed at home. I should have said, 'No, I'll never go. Never. Not over my dead body!'

MAESTRO: (*Suddenly sympathetic.*) You poor little thing. Then you would still have worn braids and fed your ma's chickens.

EZMERELDA: Yes. I would have.

MAESTRO: Oh to think what I have deprived you of.
(*He lifts her chin.*) Look at me. Look at me.
(*EZMERELDA lifts her head and looks at him.*)
If I'd gone away for ever would you have remembered me, would you have thought of me, or would you have been quite satisfied with your fat ma and your chickens?

EZMERELDA: (*Despairingly.*) I would have forgotten you. I would have.

MAESTRO: (*Stroking her cheek.*) While the fat bitch counted her money you stood there in your blue dress at the window. And I looked at you. My eyes…touched you everywhere. You could feel my eyes touching you. Could

you have forgotten that? My eyes caressing you as they are caressing you now. Your wrists…your hair…your mouth…

(*EZMERELDA looks at him. She gives a soft cry and flings her arms around him. MAESTRO presses her to him, lifting her slightly with one arm around her waist. Her feet don't quite touch the ground and he takes a few steps, carrying her.*) As you can see. (*He pushes her way. She stumbles.*) She is not under duress!

(*EZMERELDA sobs.*)

HERMIEN: (*Putting her arms around EZMERELDA.*) You are certainly no gentleman, Meneer.

MAESTRO: Not?

HERMIEN: I am sorry to say, but you have no breeding.

MAESTRO: (*Without interest.*) You're quite wrong, dear lady. I come from a very old family. Oh I see my dear assistant has not eaten all her food. There are still two drumsticks and two wings. If you can add anything, anything at all my coachman will be deeply grateful. He must be dying of hunger poor fellow. Of course I am prepared to pay more.

HERMIEN: (*Coldly.*) You don't have to pay for the meal, Meneer.

MAESTRO: And why not?

HERMIEN: I don't want to make money out of my guests. The small fee for the room is only to cover our costs. I am here to give warning against the dangerous water. I also have…other duties. But these don't concern you.

MAESTRO: But you are an angel of mercy!

HERMIEN: No. I am only doing my duty.

MAESTRO: You are a wonderful person! A most excellent person! (*He kisses HERMIEN's hand.*)

HERMIEN: (*Drawing her hand away.*) I don't want any thanks.

MAESTRO: And Ezmerelda? Why do you not show your appreciation?

EZMERELDA: (*Bowing.*) Thank you very much.

HERMIEN: (*Flustered.*) Come on Sussie, help me to clear the table.

MAESTRO: Ezmerelda can help you. She would be glad to help you, wouldn't you dear heart?

EZMERELDA: (*Unwillingly.*) Yes.

HERMIEN: Well if it's not too much trouble…

MAESTRO: Not at all. Not at all.

HERMIEN: Well…

> (*EZMERELDA gets up rather unwillingly and starts clearing the table. Loud noises and the sound of furniture being overturned can be heard from upstairs.*)
>
> Drunk again! It is always the same. (*She exits into the hall, loudly off.*) Stop that! Stop it at once!
>
> (*HERMIEN enters. They all listen until everything is quiet. Sudden laughter from upstairs.*)
>
> (*Sarcastically.*) My, but they are in high spirits tonight!
>
> (*To EZMERELDA.*) You seem to have finished in no time at all. Now if you will help me, we can take everything through.
>
> (*HERMIEN and EZMERELDA off. The clock strikes half past eleven.*)

MAESTRO: (*Sitting next to SUSSIE and taking her hand in his.*) I was just thinking…you and your sister have been so good to us and without expecting anything in return. To show my gratitude I would like to give you something.

SUSSIE: A gift?

MAESTRO: Yes in a manner of speaking. Something that only I can give you. (*He glances at her hands.*) You have such lovely hands. Delicate and pale.

SUSSIE: I…don't often go outside. I hardly ever go out into the sun.

MAESTRO: That is as it should be. A lady's skin should be delicate almost transparently thin. You should see the blood under the skin.

HERMIEN: (*Off.*) Milk and rusks make you sleep much better…

> (*MAESTRO lets go of SUSSIE's hand. HERMIEN and EZMERELDA enter from the hall. HERMIEN puts food wrapped in muslin on the table.*)

MAESTRO: I was just telling your sister that in order to show my gratitude I would like to give you something.

HERMIEN: That is really not necessary.

MAESTRO: Oh but it is. (*He gets up and moves to the landing. He bows.*) I, Maestro, will present a short entertainment. (*He holds out his hand.*) Come now Ezmerelda, we shall begin with you.

EZMERELDA: It's very late. I'm tired.

HERMIEN: This is really totally unnecessary, Meneer.

MAESTRO: It is my pleasure, dear Mevrou. (*To EZMERELDA.*) You wish to show your appreciation, don't you?

EZMERELDA: (*Pouting.*) I don't want to.

MAESTRO: Come now. You are being disagreeable.

EZMERELDA: No.

MAESTRO: How dare you behave like this? I am deeply ashamed of you.

EZMERELDA: (*Snivelling.*) I'm tired. I'm very tired. (*She gets up slowly and seems to be unsteady on her feet.*)

HERMIEN: Surely you can see she is exhausted. Look at her! Dead on her feet! And it's getting very late.

MAESTRO: (*To EZMERELDA.*) Very well. As you wish. Who else wants to join me?

SUSSIE: I do!

HERMIEN: (*Taking SUSSIE's hand firmly in her own. SUSSIE attempts to get up but HERMIEN holds her back.*) Sit, Sussie! I am telling you to sit down!

MAESTRO: I assure you there's nothing to fear. (*SUSSIE tries to get up but HERMIEN pulls her down.*)

HERMIEN: No! You can't go! You can't dabble in this hypnosis! We know nothing about it!

MAESTRO: Then this is a chance to find out, dear lady. And believe me you will not regret it. All your wildest dreams can come true. If you wish for sumptuous clothes, they will appear at once.

HERMIEN: Vanity. I do not hold with such things.

MAESTRO: What about a feast; game, lamb, tarts and cream cakes...

HERMIEN: I've eaten, thank you, Meneer.

MAESTRO: (*To SUSSIE.*) And what about you? What do you desire?

SUSSIE: (*Pulling free of HERMIEN and running up to the landing.*) To go away! Far away from here! To see other places!

HERMIEN: Oh! So, our mother's home is not good enough for you any more!

MAESTRO: Then we shall go on a journey. More swiftly than breath you will float out of the window higher and higher...the river will be a writhing snake...and the house too small to see with the naked eye...

HERMIEN: What rubbish!

MAESTRO: Perhaps you wish to go to the sea? In the wink of an eye you are there... Walking down the narrow sand path, glinting in the moonlight like a shallow stream... and there it would be...infinite reflection of the night sky...

HERMIEN: This is quite enough!

MAESTRO: Or in a dense forest? In the liquid green light under the high arches of trees...

HERMIEN: I said it's enough!

MAESTRO: Just say where and I Maestro will take you there.

HERMIEN: Sussie! Listen to me!

MAESTRO: (*Formal.*) I must ask you to be quiet. This is a very delicate matter! Before each performance I always say: 'Silence is of the most utmost importance. Even if you only wish to cough or sneeze, I must ask you to leave the hall.'

HERMIEN: So, you're telling me to be quiet! And in my own home!

SUSSIE: Please! Please! Do what he says!

MAESTRO: Look! (*He takes out his pocket-watch.*) Look at my watch.
(*He swings the watch from side to side. SUSSIE watches and in spite of herself HERMIEN follows the movements of the watch as well. Then she shakes her head vigorously.*)

HERMIEN: Stop! (*Rising.*) I say stop!! (*She rushes up the stairs.*) I warned you, didn't I? (*She grabs SUSSIE by her arm.*)

SUSSIE: Please! I want to!

HERMIEN: No!

SUSSIE: I beg you!

HERMIEN: I said no!

SUSSIE: I'll do anything. I'll repair the nets by myself even when my fingers bleed. I'll never complain again even when I dig a grave for two days!

HERMIEN: For the last time no! Over my dead body!

SUSSIE: Please! I'm begging you! (*She falls on her knees.*) Please! Please! Please!

HERMIEN: Get off your knees! Have you lost your mind! Get up! (*She pulls SUSSIE up by her hair.*) I said get up! And behave yourself! (*To MAESTRO.*) Do you see what you've done! And all because you wanted to fool my poor deformed sister with your trickery!

MAESTRO: (*Cold fury.*) Trickery! Is that what you call it? Ha! Cut and dried! Cut and dried. Oh yes, I know your kind! Everything is always cut and dried. You will never understand. Never. How I pity you. You miserable creature.

(*HERMIEN is clearly shocked.*)

But I must control myself. After all, this is only a waste of time. (*He puts away his pocket-watch. To SUSSIE.*) I am deeply sorry. (*He moves to the table and picks up the food in the muslin. Small bow.*) Please excuse me. (*He exits rapidly. Sound of the heavy front door opening and closing.*)

(*There is a few moments silence. SUSSIE is on her knees with her face buried in her hands. HERMIEN still has her hands in SUSSIE's hair. HERMIEN pushes SUSSIE away. SUSSIE falls and lies with her head in her arms.*)

HERMIEN: What a hideous man! (*To SUSSIE.*) And what possessed you? Have you no shame? (*To EZMERELDA.*) I'm so sorry for you. Bitterly sorry. Such a monster! And when I see how he treats you!

EZMERELDA: Yes. He often gets angry. Then he scolds me.

HERMIEN: Poor child.

EZMERELDA: And sometimes he hurts me.

HERMIEN: How terrible.

EZMERELDA: He never allows me to rest. He drags me from one place to the other. I am so…tired.

HERMIEN: I am sure you are!

EZMERELDA: And then all the performances. Candles and lamps shining in my eyes. And all the men looking at me.

HERMIEN: How horrible!

EZMERELDA: And the noise. Clapping, whistling and stamping! (*She touches her temples.*) It always gives me a headache. And they smell of rancid sweat and dirty clothes.

HERMIEN: Oh!

EZMERELDA: And sometimes they touch me. They touch me…everywhere.

HERMIEN: But this is terrible. What would your poor mother say? Come now. Don't cry. (*Strokes EZMERELDA's hair.*) Let me dry your tears. (*She dries her tears with a small white handkerchief which she takes out of her sleeve.*) I'll help you. Yes, I will. Trust me child. I'll save you from the clutches of this man. Let me think…there must be a way. Tell me…are you very homesick?

EZMERELDA: (*Tentative.*) Yes…

HERMIEN: But that is the answer to our problem! I must help you to go back home where you belong. Surely you'll be happy to see your home again?

EZMERELDA: It's funny… I can hardly remember my home. (*Happy.*) I remember the chickens. (*Sad.*) But I wonder if I would still know my home. If I'd still know it if I saw it.

HERMIEN: Of course you will. East west home is best. And your mother! She'll be quite overcome to see you again. Think how happy she'll be when she opens the door and there you are! She'll take you in her arms and press you to her bosom. (*She wipes away a tear.*) Forgive me but I feel deeply moved.

EZMERELDA: Yes…my ma. (*Glad.*) I'm sure I can remember her! She is a big woman and smells of rancid dripping!

HERMIEN: You'll be so happy! You'll forget…your
unfortunate past. Your life will go on as if nothing's
happened.
(*SUSSIE gets up.*)
Yes! I'll take you to the nearest station… I'll make you
egg sandwiches… I'll buy you a ticket and put you on
the train… I'll wave until the train disappears behind
the silo.

EZMERELDA: (*Uncertain.*) Yes…

HERMIEN: But then you must tell this hideous man.
You must tell him that you want to stay with us.

EZMERELDA: I don't know…

HERMIEN: You poor thing. I suppose you're afraid of him.
And who could blame you? Then there is only one thing
to do…
(*SUSSIE moves to the bedroom door.*)
(*To SUSSIE.*) Have you no manners? Don't you say
goodnight to our guest? But go! Get out of my sight!
(*She strokes EZMERELDA's hand.*) I'll speak to him.
(*SUSSIE exits to bedroom.*)

EZMERELDA: No…

HERMIEN: Yes it is probably better if you tell him yourself.

EZMERELDA: I…don't really know.

HERMIEN: There is really no time to shilly-shally! Tell
him and make it very clear!

EZMERELDA: I'm not really sure…

HERMIEN: But surely you don't want to stay as you are?
Have you no mind of your own?

EZMERELDA: It's only…sometimes he's very good to me…

HERMIEN: Oh I see.

EZMERELDA: Yes he is.

HERMIEN: I can hardly believe that.

EZMERELDA: It's true. (*Dreamily.*) Very good.

HERMIEN: The man has you in his power! (*She shakes
EZMERELDA.*) Wake up! Come to your senses!

EZMERELDA: Let me go! What are you doing to me?
I'll tell him! He'll be very angry with you!

HERMIEN: I can hardly believe my ears! Do you want to
stay with this repulsive monster?

98

EZMERELDA: He isn't a monster! He isn't! He isn't! What do you know?

(*MAESTRO appears on the landing. EZMERELDA runs to him and embraces him passionately. She turns her head and looks triumphantly at HERMIEN.*)

MAESTRO: (*Pushing her aside.*) Fortunately the rain has stopped. (*He picks up his cloak.*) The ground is still quite soggy but the air is crystal clear. And so my coachman and I have decided to continue our journey.

HERMIEN: Surely you don't mean to cross the river?

MAESTRO: Most certainly. We have to get to the other side.

HERMIEN: But the dangerous flood water. I've warned you, haven't I?

EZMERELDA: Listen to her! I'm afraid.

MAESTRO: (*To EZMERELDA.*) Put on your coat. (*He puts on his cloak and his top hat.*)

HERMIEN: You must listen to me! You're in grave danger! Listen! Please, Meneer!

EZMERELDA: I'm trembling…

MAESTRO: We are leaving! And there is nothing more to be said!

HERMIEN: Then you face certain death!

MAESTRO: And where is your sister? I wanted to say goodbye.

HERMIEN: You are a fool! Go and look! (*She points towards the window.*) Look out there!! Look at the rows of graves and white crosses!! The last resting place of those who wouldn't listen!

EZMERELDA: (*Crying.*) I'm afraid! I don't want to go! It's so dark outside…and listen to the rushing water! I'm afraid of water!

MAESTRO: It is because of her! With her prophecies of doom!

HERMIEN: Yes, possibly I am only making the situation worse! I will go to my room. You can talk about it on your own. (*She moves towards the bedroom.*) I can only hope and pray that you will make the right decision but ultimately it is your choice. (*She turns around at the door.*)

I have warned you over and over again! I have done my
best! I have done everything that is humanly possible!
I sacrifice myself but nobody ever listens!! (*She exits
banging the door behind her.*)

EZMERELDA: I don't want to go. I'm scared! I'm scared!

MAESTRO: (*He sits. Suddenly exhausted.*) Yes, yes, yes! You
are always scared or tired or cold. I know.

EZMERELDA: That's not true!

MAESTRO: Yes it is. (*Silence. He drops his head into his
hands.*) The same lament. Just like all the others.

EZMERELDA: I'm not like the others! (*Sobs.*) I'm not!

MAESTRO: At the beginning I'm always so glad because
I think I have found someone to go on my journey with
me. Someone to hold through the long nights in all the
desolate places. And I won't have to be alone any more.
Not so…utterly alone. (*Short silence.*) But then it starts
again. You always want something every moment of the
day. Food, clothes, or love…and if you don't get what
you want then you look at me. Always looking at me.
Even in the dark. And every time the loneliness becomes
more and more unbearable. I am consumed with
longing. I burn with loneliness. (*He lifts his head and looks
at EZMERELDA.*) I show you visions of strange places
and other times. In one moment you live many years.
You drift weightless or lie in a perfumed garden half-
hidden under rose petals and jasmine. Or you sing and
see your song unfurling like a golden feather. And at
night all night you lie in my arms with my breath
against your hair. This is what I give you. But no! This
will not do! What you want is a warm bed, a bowl of
soup and a thick slice of bread! That is not life! That is
death!

(*EZMERELDA sobs.*)

I should have left you with the fat slut and the chickens.
Yes, that is what you all are. Soft and simple-minded.
Maybe I need a real woman. A real woman with blood in
her veins. (*Short silence. Sudden thought.*) A woman…like
Sussie!

EZMERELDA: Sussie!

MAESTRO: Yes! Sussie! I immediately sensed that she is a warm-blooded, passionate woman. Did you see her eyes shining when she looked at me? How her whole body glowed?

EZMERELDA: But she is misshapen!

MAESTRO: (*Getting up, excited.*) Her unusual proportions are simply another sign of her exceptional nature! She is different from other people! She wishes to be free of her day-to-day existence. Like me, she wishes for life and more life! Yes…such a woman will be a true assistant. You can stay here if you wish. I will take her with me. (*The clock strikes a quarter to twelve.*)

EZMERELDA: (*Desperately.*) But the clothes won't fit over her hump!

MAESTRO: I shall have an entire trunk of new clothes made for her. To reveal her exceptional attributes! (*EZMERELDA starts crying bitterly.*) Stop crying. I have already told you you can stay.

EZMERELDA: But you said you loved me.

MAESTRO: Yes, of course. That is what I always say over and over again. It is what you want to hear, is it not?

EZMERELDA: And you said forever and ever. (*She sniffs.*) Isn't that true?

MAESTRO: Yes, I know. I always say that to please you.

EZMERELDA: (*Crying.*) And now you want her and not me!

MAESTRO: Oh stop snivelling!

EZMERELDA: What will I do without you? What will become of me?

MAESTRO: Here it starts again. I should have known. The same refrain!

EZMERELDA: I'll go with you if you want me to! Even if it's dark outside! Even if the water's deep!

MAESTRO: Did I not say you could stay? (*He smiles.*) Soon my new assistant and I will be on our way. And this time…everything will be different. (*He moves towards the stairs.*)

EZMERELDA: (*Clinging to his legs, sobbing.*) Please, please don't leave me! Please! I'm nothing without you! Oh please!

MAESTRO: (*Wearily pushes her away.*) Very well then. Come on! We have a long way to go! (*He moves rapidly to the landing.*)

EZMERELDA: (*Still on her knees.*) Maestro!

MAESTRO: (*Turning around.*) Yes?

EZMERELDA: You must say it.

MAESTRO: Say what?

EZMERELDA: You haven't said it today: 'Ezmerelda, I love you.'

MAESTRO: Ezmerelda! Ha! You are all the same. Ezmerelda. At first you are all Ezmerelda. But in time you all become… Johanna Gertiena again or…Petronella Magdalena or (*Gesture.*) what is your name? It has slipped my mind. Of course (*Gesture.*) Maria (*He laughs.*) Maria Elisabet.

(*MAESTRO laughs. He picks up the lantern and moves to the hall arch. EZMERELDA gets up and stumbles after him.*)

(*Off, sarcastic.*) Maria Elisabet! (*Further away.*) Maria Elisabet!

(*EZMERELDA exits. The resounding sound of the heavy front door closing. For a moment the stage is in darkness while the sound of the rushing river can still be heard. The sound of soft rain is faded up.*)

HERMIEN: (*As EZMERELDA. In darkness. Softly. With wonder.*) Maria Elisabet…

(*Lights slowly up. The lamp throws a circle of light on the table. The rest of the stage is in darkness. As during the 'seance' scene, HERMIEN and SUSSIE are sitting at the table. They are dressed as they were at the beginning of the play. HERMIEN is wearing SUSSIE's woollen shawl over her shoulders.*)

(*As EZMERELDA. Softly.*) Maria Elisabet.

SUSSIE: (*Leaning over and takes HERMIEN/EZMERELDA's hands between her own.*) Yes.

HERMIEN: (*As EZMERELDA. Joyously.*) Maria Elisabet!

(*Very slowly her eyes close and her head drops onto her chest. SUSSIE pulls away her hand and SUSSIE's whole attitude changes at once.*)

SUSSIE: (*She watches HERMIEN for a few moments.*) HERMIEN! (*Very loudly.*) HERMIEN!!

HERMIEN: (*Starting. Her hand jerks back and she opens her eyes.*) You nearly frightened me to death!

SUSSIE: I'm sorry.

(*She turns aside. She smiles to herself. She looks radiantly happy.*)

HERMIEN: I really don't feel very good. Not quite myself. Quite lightheaded. I have a stiff neck and my throat is parched. She seems to have had a great deal to say.

SUSSIE: Yes. She…said a great deal.

HERMIEN: Tell me were you successful?

SUSSIE: Yes.

HERMIEN: So she remembered her full name?

SUSSIE: Yes.

HERMIEN: Oh thank heavens! Now we'll be relieved of her unquiet spirit. By the way, what is her name? (*She sighs.*) Oh never mind. Help me up. I've been sitting for a long time and now my leg has gone to sleep. You can tell me tomorrow.

(*SUSSIE helps her to get up and holds her arm.*)

I'll have to walk a little to get the life back. (*She walks in a circle with SUSSIE holding her arm.*)

SUSSIE: She said she'd been here. That she'd been here before.

HERMIEN: Well it is no wonder we didn't recognise her. She'd been under the water for far too long. Oh well that feels better. I think I might sit again.

(*HERMIEN sits on the ottoman. SUSSIE lights the lamp on the desk.*)

Did she mention when?

SUSSIE: (*Bending over the lamp. Tenderly.*) She was here with Maestro. The hypnotist.

HERMIEN: That monstrous man. As though I'll ever forget him. (*She sighs.*) Poor little thing. I remember her well. Pretty and sweet-natured. Yes, I knew she was in

grave danger. I wanted to save her from him. I remember now I wanted to send her home. But it was far too late. He had her in his power. Then they left with the river in full flood. There was nothing I could do. Sometimes... I feel so tired. What is the use? (*She sighs.*) I ask you. (*She wipes away a tear with a small white handkerchief she takes from her sleeve. Suddenly bitter.*) And what happened to him? We never found him. But then monsters like that always survive.

SUSSIE: (*Softly.*) Yes.

HERMIEN: You must put her name on the cross without delay. She might be calm for the time being but she won't go away until it is all over and done with.

SUSSIE: Yes.

HERMIEN: (*Watching SUSSIE.*) What is wrong with you? You look...funny.

SUSSIE: It's nothing.

HERMIEN: What are you trying to hide?
(*The rain suddenly becomes louder.*)
Listen! That's what I was afraid of. (*She shakes her head.*) The rain is early this year. Yes the winter is over. (*She sighs.*) I enjoy the winter. To sit in the sun. To crochet or knit. To rest. Oh, what am I thinking? (*She points upwards.*) I must warn them at once. They must not leave tomorrow as they'd planned to do. It would be most perilous. (*She gets up. Notices the shawl around her shoulders.*) And why am I wearing your shawl?

SUSSIE: It was for her. She was cold.

HERMIEN: (*Taking off the shawl and draping it over the chair.*) Yes, poor thing, she was half-frozen. (*She sighs, moves quickly to the hall arch.*) I'll be back soon. You must get some rest. (*She exits.*)
(*SUSSIE remains motionless for a while. Then she gets an expression of joyous abandon on her face and throws her head back. She sighs deeply. She gets up slowly and moves towards the window. Far off the sound of HERMIEN's knock on the door. SUSSIE remains motionless in front of the window and then she opens the curtains. She stands back and looks at*

*her reflection in the dark window. She undoes her plait. She
closes her eyes and lays her cheek against her hair.*)
(*Off.*) And the same to you!
(*SUSSIE looks at herself one more time and then closes the
curtain. She goes back to the ottoman and sits in the
same place.*)
(*Off. Closer.*) Now those are sensible young people.
(*HERMIEN enters. The rain becomes softer. In her one hand
she is holding a small muslin parcel.*) It is five to twelve! No
wonder I'm so sleepy. (*Happy.*) They immediately
realised the danger. Thank goodness. They'll stay until
it's safe. (*She moves to the desk.*) Yes, sometimes it is all
worth while after all. What a consolation. (*She puts the
small parcel down on the desk.*) He was so thankful the dear
young man. He gave me a piece of wedding cake to
show his gratitude. (*She opens the muslin parcel.*) Look
how pretty.

SUSSIE: (*Getting up.*) Let me see!

HERMIEN: With small white roses.

SUSSIE: (*Standing next to HERMIEN.*) Yes, it's lovely.

HERMIEN: Unfortunately I don't have a sweet tooth.

SUSSIE: Will you give it to me? Please.

HERMIEN: If you like. but you mustn't eat it at this time
of night. You'll get heartburn.

SUSSIE: (*Folding the muslin.*) I won't eat it.

HERMIEN: (*Blowing out the lamp on the desk.*) Well, let me
go to bed. Tomorrow our work begins again. We have to
look over the nets, the ropes, and the hooks. We must
also order some more crosses, don't forget. We're almost
out of them. (*She turns.*) Go outside now and write her
name on her cross.

(*SUSSIE remains motionless with the piece of wedding cake
on her palm.*)
You're not going to eat it at this hour are you?
(*SUSSIE turns her head away.*)
Don't tell me...but surely it can't be! Sussie, do you
intend putting that piece of wedding cake under
your pillow?

(*SUSSIE drops her head.*)

You know it is only for young normal girls who wish to dream of their prospective bridegroom. Who could you possibly dream of? Who would ever marry you? You must accept things as they are. There's nothing else to do. (*She sighs.*) Poor, poor Sussie.

SUSSIE: That's not my name!

HERMIEN: Well! It's always been good enough for you until now! (*Coldly.*) If it's all the same to you, I am going to bed.

(*A loud rushing sound.*)

Do you hear that?

SUSSIE: Yes.

HERMIEN: It is the river bursting its banks. How terrible. (*She sighs.*) Well, we should get some sleep. Who knows what awaits us tomorrow. (*She moves towards the bedroom. She turns her head.*) And why are you still sitting there? Do what I told you to and then come to bed.

SUSSIE: In a while.

HERMIEN: Well, just don't leave it too long. (*She exits banging the door behind her.*)

(*The lamp throws a circle of light on the table and the rest of the room is in semi-darkness. SUSSIE is only dimly seen as she moves to the armchair and picks up the shawl. She moves to the table. When she gets to the table she puts the cake down carefully and drapes the shawl around her shoulders. Her movements are slow and dreamy. She sits on the chair occupied by HERMIEN/EZMERELDA during the 'seance' scene. Her palm rests on the wedding cake. For a few moments she sits motionless and only the ceaseless rain can be heard.*)

SUSSIE: (*After a silence. Dreamily.*) I don't have to sleep because I'm dreaming already. (*Silence.*) I dream…of the rain… I dream…of the big house with all its rooms…with all the doors…and all the windows… I dream…of a coach drawn by two black horses…the coach is getting closer and closer in the rain…through thunder and lightning and sheets of rain, the coach is

getting closer. (*Silence while she listens.*) The horses' hooves are muffled by the damp ground but I can hear them.

(*The sound of a coach approaching.*)

Everything is dark… There is nothing but a thin white feather of smoke rising from the chimney…a man gets out of the carriage…a tall man…with burning eyes… (*She gets up slowly.*) Now he is in front of the big door… he pushes against the door…the door opens.

(*The sound of a heavy door opening. The wind blows leaves into the room.*)

He stands at the door…he sees her at the table under the lamp…she doesn't look around but she knows he is there…she feels his eyes on her…

(*The clock strikes twelve.*)

(*Speaking over the striking clock.*) His eyes touching her hair, her temples, her wrists, her throat. (*She pulls a button off her nightgown.*) She hears his voice. (*She pulls the memento tin closer.*) Softly, softly murmuring. (*She opens the tin and drops the button into the tin.*) 'Ezmerelda… Ezmerelda… Ezmerelda… I have come for you…'

(*She closes the tin almost tenderly. Then she lifts her eyes and looks at the doorway leading to the hall. Slowly she starts moving towards the door. She seems slightly dazed and moves like someone walking in their sleep. The wind lifts her hair and her shawl. Her hair blows across her face. As the sound of the rushing water intensifies, she slowly climbs the steps and then exits.*

As the lights slowly fade to black, the sound of rushing water becomes louder and louder until it seems to engulf the audience.)

The End.

MIRACLE

a tragi-comic Miracle play
in two acts

translated by
the author & Steven Stead

Characters

DU PRE
A striking, theatrical eccentric, aged sixty-five.
He has a thin moustache, and he combs his fine,
unnaturally black hair in a middle parting. His face is
made-up, and he wears rings on his fingers. At the
start of the play he is dressed in dusty, black trousers,
a once white shirt with a cravat, and a black woollen
cape lined in frayed red satin. He wears a
broad-brimmed felt hat perched at a jaunty angle.
He speaks in an exaggerated theatrical manner.

SALOME
A delicate, sixty-year-old woman. She is heavily
made-up, and her behaviour is that of a young girl.
At the start of the play she wears a turban and is
dressed in a woolly, pink dress, jumper and worn
shoes, decorated with bows.

ABEL
An enthusiastic, helpful young man of about
twenty-eight. At the start of the play he wears
brown corduroy trousers and a jersey.

LENIE
A fragile young girl with long hair. At the start of
the play she is dressed in a light coloured, dirty
woollen dress, over which she wears a thick
cardigan. Her shoes are flat and plain.

ANTOINE
A fretful, neurotic man of about forty. At the start of
the play he is tall, thin and balding slightly. He wears
worn trousers, a creased shirt, a cravat, a green
corduroy jacket and a Russian cap.

ANNA
A stout woman of fifty. She has a full mouth, a
pale face and wears her hair in a bun. Her
appearance changes as indicated in the text.

Setting: an old, abandoned deconsecrated Roman Catholic church in a platteland town. The high stained glass windows are suggested by the lighting, which casts the patterns and shades of the windows over the floor and furnishings. The smaller rear section of the stage is joined to the large, lower forestage by means of a few steps. This higher level forms a natural second 'stage' and is used as such during the course of the action. On this higher level there is an altar, several old prayer benches, ordinary benches and a couple of long tables. On the lower level, there is a stack of dilapidated folding chairs. Everything is covered in dust. Clumps of dry winter grass grow through the cracks in the floor. A heavy double-door links the church with the outside world. We see the church in diagonal, with the 'stage' comprising the upper left corner of the space, and the double-doors in the upper right-hand corner. There is a carved, wooden frame around the second 'stage' formed by a pillar in each corner joined by heavy crossbeams.

Time: the third week in August 1936, during the Great Depression.

First Act: Late morning.
Second Act: Early afternoon.

ACT ONE

Voices outside the church. A door bursts open.

SALOME: (*Enters, looks around.*) Just as I thought! It's
a pigsty!
(*Exits. The door stays open, and the voices become clearer.*)

ANTOINE: (*Off.*) I told you so!

SALOME: (*Off. Shrilly.*) I shouldn't have expected
anything else!

DU PRE: (*Off. Bellowing.*) Stop whining!
(*ABEL and ANTOINE appear carrying a large skip full of
costumes.*)

ABEL: No, wait. Turn the skip around.
(*Sound of a steam train whistling.*)

DU PRE: (*Off.*) Don't be ridiculous. Open the other door!
(*The other door is given a hefty kick and it opens. ANTOINE
and ABEL enter with the skip.*)

ANTOINE: God, this thing is heavy! (*He wants to put his
end down.*)

SALOME: (*Appearing in the doorway. She is carrying a large
bundle and an old suitcase.*) You can't just put it down right
here in front of the door. You should put it down over
there, in the middle. Some town! All I saw in the streets
were sheep! (*Looking up.*) The windows are broken!
(*DU PRE appears carrying a trunk. He lowers it to the ground
and looks around. ABEL exits through the doors.*)

ANTOINE: We'll freeze to death in here. It's like a
mausoleum!
(*Sound of a steam train leaving the station.*)

SALOME: Last time at least we could hire the school hall.
Now this!
(*LENIE enters. She is carrying a bundle and ABEL carries
her two heavy suitcases.*)

ANTOINE: She gets everything done for her. The rest of us
just have to cope. Look at my blisters!

DU PRE: (S*ternly.*) Come on, we have work to do. Open up
and unpack!

ANTOINE: We're exhausted!

(*LENIE sinks down on a chair.*)

ABEL: Please, can't we just rest a bit first?

DU PRE: Rest? Why on earth? You snored all night long on the train!

ANTOINE: Who even gets to shut their eyes in the poor-white carriage?

(*Sound of a steam train leaving the town.*)

SALOME: (*Looking around.*) And everything's full of dust. We'll have to clean the place from top to bottom. And bird-droppings. Ugh.

DU PRE: Unpack the costumes! Or they'll be full of creases tonight. Spread them out on the benches. The props and make-up can go on the table. Then we'll hang the curtains. (*Sees the altar on the raised level.*) Here! We shall play here! (*He stands behind the altar.*) And the altar is mine. It's perfect for God.

ANTOINE: I thought we were doing *Ampie*.

DU PRE: No! *Everyman*! (*A majestic gesture.*) This is the right place for *Everyman*. And anyway, how can we play *Ampie* without a donkey? All the animals around here are half dead. Skin and bone.

ABEL: It's been months since we played *Everyman*, Meneer.

SALOME: Months. I can't remember my words. How am I supposed to remember my words? I don't want to make a fool of myself.

ANTOINE: (*Aside.*) You do that anyway, love.

SALOME: I heard what you said. (*To DU PRE.*) Did you hear what he just said to me?

DU PRE: For God's sake, stop bickering! I've had enough! Well, we're just going to have to work very hard that's all. (*To SALOME.*) Stop snivelling! What are you all sitting around for? Didn't you hear me? Get to work!

(*The sound of the steam train fades away into the distance.*)

SALOME: (*Strident.*) And where is my trunk? Where is it?

LENIE: There.

SALOME: Not that one! My costume trunk! Where is it?

ABEL: Maybe it's still outside.

SALOME: (*Running outside and appearing again almost immediately.*) No! It's gone! It's gone!

DU PRE: Calm down. It's not the end of the world!

SALOME: (*Beginning to cry pathetically.*) Everything's inside it. Miranda's silks... Juliet's cloak... Nora's ringlets... (*Sobbing in earnest.*) Iphigenia...

DU PRE: There darling, there now. We'll get it back, you'll see.

ABEL: Maybe it got left on the train.

LENIE: Maybe it's still at the station.

SALOME: (*Stamping her foot like a child.*) I want it back! I want it back! (*To DU PRE, pointing at ANTOINE.*) Send him back to the station! Tell him to get it for me! Tell him he must! At once!

ANTOINE: It's freezing outside! It's white with frost! (*Aside.*) Bitch.

SALOME: (*Very excited, almost triumphant.*) And what am I supposed to wear tonight in *Everyman*? Beauty's dress is also in there.

DU PRE: Don't upset yourself. We'll find you something to wear. The skip is full of costumes.

SALOME: How can you call those rags and patches costumes? Bits of old tat!

ANTOINE: (*Snidely.*) No, they aren't up to much, are they? Soiled cast-offs. Honestly, I don't know how you can expect us to wear them.

DU PRE: You fools! You're like the crows with the feathers! You honestly believe they'll turn you into fine birds, don't you? An artist, a true artist can make magic with a feather, a cardboard sword, a pair of broken shoes! Transformation! That's what I keep telling you, but you refuse to understand! You understand nothing! (*Roaring.*) Nothing! (*He falls against the door with his head buried in his arm.*)

ANTOINE: (*Concerned.*) Come on, don't upset yourself. You know it's not good for you. Come on. Come on. (*He touches DU PRE's shoulder.*)

DU PRE: Don't touch me! You vile thing!

(*Short silence.*)

(*Tired, passing his hand over his eyes.*) Ah. What does it matter? (*He claps his hands.*) Come, to work! There's no time to lose!

(*LENIE groans. ABEL puts his arm protectively around her shoulders.*)

What's wrong with her now?

ABEL: With all due respect, Mr Du Pré, the last time we ate was yesterday afternoon.

DU PRE: What are you trying to say?

ABEL: We're hungry, Mr Du Pré. We're hungry.

DU PRE: Is that so? You play Hamlet once, and now listen to you!

SALOME: (*Shrieks.*) What's that flying around? It's a bat! I'm scared of bats. They fly into your hair and no one can get them out!

ANTOINE: It's a dove, love. Bats don't fly in bright daylight. (*Taking his soiled handkerchief out of his pocket.*) And they don't shit on your clothes! (*He wipes bird-droppings off his shoulder.*)

ABEL: It's true, Mr Du Pré. We've worked for three months without pay. I haven't complained, but we must eat. Look at Lenie. She's weak and dizzy with hunger.

SALOME: Yes! I don't feel very well either. I didn't sleep a wink last night. How could we be expected to in the poor-white carriage? Lenie and I were sandwiched between two fat women in mourning. Reeking of sweat and cheap scent.

ANTOINE: And such an old train. It stopped for every milk can and every cow on the tracks.

DU PRE: What is it with you? Do you want to run off like the last lot? Go and join the circus? Play in Vaudeville? Become clerks? Janitors?

ABEL: No. That's not what we mean, Meneer.

DU PRE: Well, what then?

ABEL: We just want to stay alive, Meneer.

DU PRE: (*Sarcastic.*) Is that all? Oh, do forgive me. I had almost forgotten. The mother-to-be. The concerned father. Please, spare me! Don't you know anything?

Don't you understand anything? To act is to endure
hunger. To embrace exhaustion. And to sacrifice! It is
your birthright. Would you rather be bloated, soft and
self-satisfied? Tja! (*Suddenly gentle and calming.*) You
mustn't despair. We have been through hard, hard times.
(*Spirited.*) But tonight is the beginning of better things.
I know it. Here, in this place, everything will begin
afresh. Yes, hereafter, everything will be different. Trust
me. Tonight we will play to a full house.

ANTOINE: Where are they going to sit?

DU PRE: Quiet! What do you know? (*Inspired.*) They will
stand. Like the audiences of yesteryear. Trust me!
Tomorrow we'll travel first-class. And we will go to a big
city. Kroonstad or Bethlehem! And this time we will
perform in a real hall! We'll find more actors. It will be
our new beginning!

SALOME: (*Excited.*) New costumes!

DU PRE: Of course.

SALOME: Silk and brocade and feathers!

DU PRE: Oh yes!

ANTOINE: But that's what you always say.

DU PRE: This time it's different!

ANTOINE: And if it doesn't happen? If nobody comes
tonight?

DU PRE: I do not know! Then I'll kill myself! But it will go
well! You'll see. We must just work hard now. And get
everything right. You'll see. It must work! Abel, Antoine,
hang up the curtains. Lenie, unpack the props, and
Salomé, the costumes.
(*SALOME weeps.*)
What is it now?

SALOME: All…all the roles I have ever played were in
my trunk.

DU PRE: (*Soothing.*) There, darling, we'll get it back.

SALOME: (*Weeping bitterly.*) Everyone I've ever been. (*She
sniffs. She wipes her hand over her nose.*) All the years…
My life… (*She cries as though her heart would break.*)

DU PRE: (*Sitting next to her, stoking her hair.*) Don't weep.
My poor little one. (*Taking out a dirty handkerchief and*

117

wiping away her tears.) My darling girl, don't weep.
I'll make everything better. Yes, I will. You'll see. There
dear, my angel. I'll get it back for you, you'll see.
Antoine, go to the station and look for the trunk!

ANTOINE: It's cold outside.

DU PRE: If you run you'll stay warm. And it's not far. What
are you standing about for? Hurry! (*To SALOME.*) There
now, there now. Dry your eyes.

ANTOINE: It's always the same. Whatever she wants,
she gets.

(*Sound of a cold, howling wind.*)

DU PRE: That's right, yes.

ANTOINE: And I'm expected to do the dirty work!

DU PRE: That's right, yes.

ANTOINE: What for? I never even get a decent part. It's
always him. Why don't you ask him? (*He points at
ABEL.*) He does everything better than I do!

DU PRE: Not everything! You're the one who is always at
my beck and call. You are cringing and subservient by
nature. You enjoy it! (*Bellowing.*) Now go before I lose
my temper!

(*ANTOINE hesitates for a moment and then leaves quickly.*)
(*Rocking SALOME to and fro gently.*) There now.
There now.

(*LENIE shudders.*)

ABEL: What is it? What's wrong.

LENIE: That howling wind. It frightens me.

DU PRE: (*To ABEL and LENIE.*) No time for lovey-dovey.
You have work to do.

(*ABEL and LENIE begin to unpack the props from the skip.*)

ABEL: Let's unpack them onto the table. (*He starts.*) What
was that?

LENIE: I didn't hear anything.

DU PRE: Your little hands are so cold. (*He blows on
SALOME's hands, and rubs them in his own. Softly sings
'Your Little Cold Hand' from 'La Boheme'. He sings it
'tongue-in-cheek' and hums where he forgets the words.*)
(*ABEL and LENIE unpack. DU PRE rubs SALOME's hands
and continues to sing softly.*)

ABEL: I can hear something. Maybe someone is trying to get in.

SALOME: And my feet too.

DU PRE: Dear girl. Your poor little feet. (*Speaking in a high voice.*) Poor…poor…poor little feet.

(*ABEL goes to the door, opens it and looks out. He closes the door again. He goes back to LENIE. While they work, DU PRE takes off SALOME's broken, old shoes and rubs her feet.*)

LENIE: Look. (*She takes out a pair of angel wings. Very worried.*) Look. The one wing is cracked. (*Curious.*) Was there anyone there? At the door?

ABEL: No. We'll have to fix it. Here, take the crown.

DU PRE: Is that better?

SALOME: Yes, warm little feet.

(*The wind drops. DU PRE sits next to SALOME, and she leans her head on his shoulder. He rests his chin on her head.*)

DU PRE: Salomé, I'm a bit dizzy and I feel a little tired.

SALOME: All we need is rest and then we'll feel better, Noekie, you'll see.

DU PRE: You're right. We must rest.

LENIE: The sword hasn't got a point.

ABEL: It's the only one we've got.

(*There is a short silence. LENIE looks at SALOME and DU PRE who are leaning against one another, eyes closed. The dialogue between ABEL and LENIE is almost whispered as though they didn't want to disturb the sleepers. Throughout their dialogue, DU PRE snores softly.*)

LENIE: So…we're back were we started.

ABEL: Yes. We met in this town.

(*Short silence.*)

LENIE: Are you going to see her?

ABEL: Who?

LENIE: Your wife. She lives here, doesn't she? Doesn't she?

ABEL: Who told you?

LENIE: It's true, isn't it? You have a wife.

ABEL: Antoine of course. He should mind his own business.

LENIE: Why didn't you tell me? Why not?

(*ABEL turns his head away.*)

You said you loved me.

ABEL: Yes.

LENIE: Forever and ever.

ABEL: Yes.

LENIE: I don't believe you any more.

ABEL: It's true. It's true. You know it's true.

LENIE: (*Taking ABEL's hand and pressing it to her stomach.*)
This is our child. Yours and mine. You said you'd make
everything right. You promised. I want to be your wife,
Abel, but I can't be.

ABEL: I know.

LENIE: Why didn't you ever tell me? You put it off and
put it off. Never the right place. Never enough time. But
now I know why. Because you're her husband. You
belong to her.
(*ABEL doesn't answer.*)
Is it true? Do you want her and not me?

ABEL: No! That's not true!

LENIE: Then you must go to her. And you must tell her
about me.

ABEL: (*Anguished.*) I can't!

LENIE: Why not?

ABEL: Because I'm afraid of her.

LENIE: Why afraid?

ABEL: You don't know her! I can't see her! Something will
happen. She is a terrible woman.

LENIE: Then why did you marry her?

ABEL: I'm not married to her. I sold myself to her.

LENIE: Sold?

ABEL: (*Sitting, looking down at his hands.*) When the
Depression started, my family sold our land. They
bartered it away, bit by bit. Our farm got smaller and
smaller. My father and brothers went away to the city. To
the mines. My mother and I stayed behind on the farm.
The misery was killing her. That's when the widow
appeared. With pots of lentil soup. She was very rich,
with two kaffirshops in the town. Her big, white house
had soft carpets and thick curtains. Roast lamb, venison,
cream tart. I was tired. So tired. When she asked, I said

yes. (*Pause.*) I married her, but it was for nothing. Not long afterwards my mother died. During the day I was behind the counter. Acid drops, hessian, and chicken feed. She stayed in the house. Waiting for me. She was never my wife! She was my punishment! And then, one night I saw you on the stage in the city hall. The whole world changed. That night I went away with you. Without saying goodbye. I swore that I would never come back.

LENIE: But you have!

ABEL: What else could I do? We couldn't afford to go any further.

ANTOINE: (*Entering, out of breath.*) Just as I thought. Nothing! (*He sees DU PRE and SALOME sleeping.*) Just look at them. Him snoring and her with her mouth open. They're getting old. Shame. Maybe a bit senile too.

ABEL: Be quiet!

ANTOINE: Oh, excuse me! Mr Decency.

SALOME: (*Starting awake.*) Oh! I must have dropped off. I feel like a new person. (*She sees ANTOINE.*) Was it there? What did they say?

ANTOINE: There was nothing. They'll ask at the next station.

SALOME: Merde! (*To DU PRE.*) It was his fault! (*Pointing at ANTOINE.*) He was supposed to take care of the baggage! (*DU PRE wakes suddenly, slightly bewildered.*)

ANTOINE: If that trunk was so important to you then you should have looked after it yourself!

DU PRE: (*Getting up.*) She's absolutely right. You're negligent and untrustworthy.

SALOME: And this isn't the first time either!

ANTOINE: It's always *my* fault! I'm just a skivvie! That's all I am. (*With feeling.*) A skivvie!

DU PRE: (*To ANTOINE.*) Come now. (*Running his finger almost seductively down ANTOINE's cheek.*) Don't be naughty now. Be a good boy. That's it. (*He turns around and claps his hands.*) Curtains first! Lenie, get the curtains. (*While he speaks, LENIE moves quickly to the skip, opens it and takes out two old, red velvet curtains.*)

121

Everyone must help. Abel, Antoine, pull the tables
together. Where are the hammer and nails?

ANTOINE: Here.

DU PRE: (*Friendly.*) Thank you, Antoine.

(*LENIE gives the curtains to DU PRE, and he gives them
to ABEL.*)

Now. Antoine and Salomé hold that end up, Abel and
Lenie the other. I'll stand back to observe the symmetry.
Come along! What are you messing about for?

SALOME: I'm too short. I can't reach.

DU PRE: Well, just drop it then! A little higher on the right.

SALOME: You don't have to speak to me like that!

DU PRE: Drop it down a little.

SALOME: I'm a very sensitive person.

ANTOINE: Hurry up. My arms are going numb. (*He sniffs.*)

DU PRE: (*Giving the hammer and nails to ANTOINE.*) Make
sure it's caught nice and tight.

(*ANTOINE sniffs again.*)

You and your runny nose! Your eternal sniffing!

SALOME: I shouldn't be doing things like this in any case.

ANTOINE: (*To DU PRE.*) I can't help it. It's all the draughty
buildings and the cold trains.

DU PRE: Is it secure?

ANTOINE: (*Surly.*) It's secure.

SALOME: I haven't had time to do anything about my
appearance. And I have a public to consider!

(*DU PRE gives the hammer and nails to ABEL.*)

(*Loudly, above the banging of the hammer.*) I mean, somebody
could turn up here at any moment.

ABEL: (*Stopping hammering.*) Why do you say that? Who do
you mean?

SALOME: Its possible, isn't it? An admirer.

DU PRE: And what difference does it make? Get on with
the work.

(*While ABEL hammers, SALOME takes off her head-scarf.
Her fine, grey hair is flattened untidily around her head.*)

Yes. That looks right. I hope it's secure. The tabs must be
able to open and close smoothly.

ABEL: (*Enthusiastically.*) I think it'll hold.

SALOME: (*Busy putting on a curly, blonde wig, which looks used and thin.*) My public have always adored me.

ANTOINE: They don't remember you any more, love.

DU PRE: Watch your mouth!

SALOME: (*Looking at herself in the mirror, primping her wig.*) My photo always goes in the bookshop window. One with my head to one side and my hand just so on my cheek.

DU PRE: Close them, Lenie. Let me see.

(*The curtain closes jerkily.*)

SALOME: Noekie, you mustn't forget to put my photo in the window.

DU PRE: Of course, my angel. We shan't forget.

SALOME: (*Looking at herself in the mirror, she gives a small gasp.*) Oh, just look at me. I hardly recognise myself. (*Smearing rouge on her cheeks.*) It's because I've not been getting enough sleep. All I need is a good night's sleep.

ANTOINE: (*Softly to DU PRE.*) We can't do it any more. A photo from nineteen-voetsek just makes us look ridiculous.

SALOME: I've always needed my beauty sleep.

DU PRE: (*Hissing at ANTOINE.*) I'm warning you! Lenie, you open the curtain tonight.

LENIE: Yes, Meneer.

DU PRE: As the tabs open, I shall be standing at the altar with my angel over me. But before that, just my voice will be heard: (*Resonant.*) 'I see here in my majesty, how mankind reviles me. He lives without fear in this world. He sees not my signs and is blind!' On 'Sees not my signs and is blind!', open the tabs slowly. Have you got that?

LENIE: Yes, Meneer.

SALOME: (*Putting on lipstick.*) But don't open them all the way. There has to be some space for us to change backstage.

DU PRE: All the way.

SALOME: But you can't do that!

DU PRE: If I don't, the stage will be too small.

SALOME: (*Shrill and very upset.*) But I've got three costumes! Where am I supposed to change? And what about my make-up? I refuse to work under these conditions! I refuse!

DU PRE: (*Suddenly furious.*) For God's sake, stop whining, you silly, old bitch!
(*SALOME presses her hand over her mouth and begins to cry high and hysterically.*)

ANTOINE: She's right! We're better than this. Who can work like this? I mean honestly we have our standards after all.

DU PRE: (*Loudly, to be heard above SALOME's hysterics.*) You cringing, spineless creatures! I've had enough! I can endure no more! What do you know about art? Of higher things? Tja! You don't deserve me! I'm wasting my time. (*He sweeps his cloak around him.*)
(*SALOME is suddenly quiet.*)
I'm leaving now. (*He puts on his hat.*) I never want to set eyes on you again. Vermin! Amateurs! (*He begins to move rapidly towards the door.*)

SALOME: (*Running after him, and clinging to his sleeve.*) Wait! Please! Don't leave! Please! What will I do? Please don't leave me…

DU PRE: (*Roaring.*) Get your paws off me!

SALOME: Please, please. We're sorry. Very sorry. Antoine is also sorry, aren't you?

ANTOINE: (*Mumbling.*) I'm sorry.

DU PRE: Let go of me! You nauseate me with your fishy old-woman smells!

SALOME: Please! Please! Abel and Lenie are sorry too.
(*DU PRE pushes SALOME away. She stumbles and falls against the table. She makes a whimpering sound. As though he were changing roles, DU PRE's anger instantly disappears and is replaced by a sarcastic, amused expression. He laughs softly. Then louder. He moves towards ABEL and LENIE.*)

DU PRE: Abel and Lenie! (*He laughs.*) How funny. What has become of the theatre? (*He laughs.*) Abel and Lenie. Abelard and Leonora. Those are names! But no! They

want to retain their own, their 'proper' names. It's quite touching, isn't it? So naïve. So…sincere. (*Suddenly running out of steam.*) Own names, own names…what's all that supposed to mean? You call yourselves artists? Phaedra, Lovborg, Agamemnon, Jasmine! So many to choose from, but no, you're quite content with… (*He laughs.*) Abel… (*He laughs.*) and…Lenie. (*He takes his hat and cloak off. Suddenly very business-like to LENIE.*) Well, light the paraffin stove for the iron, and iron the costumes. (*To SALOME.*) And what's wrong with you?

SALOME: It hurts.

DU PRE: Where? Show me.

(*SALOME pulls up her sleeve and shows him a bruise on her arm.*)

Poor arm. (*He kisses the bruise and makes extravagant kissing sounds.*) Is that better?

(*SALOME nods.*)

(*To ABEL.*) Are the props in order?

ABEL: Yes, Meneer. But one of the angel's wings is broken.

SALOME: My wing!

DU PRE: Well, fix it.

LENIE: (*With the paraffin can in her hands.*) It's empty, Meneer.

DU PRE: Well, fill it.

LENIE: It's finished, Meneer.

SALOME: Noekie! The paraffin's finished. What are we going to do about lighting?

DU PRE: Never mind. We'll buy more.

ANTOINE: With what?

DU PRE: With tickets! We give them two, or even three!

SALOME: They never want them.

DU PRE: (*Mimicking her high voice.*) 'They never want them'. And who asked you?

(*ANTOINE goes and sits in the corner. He takes out a half-jack from his pocket and surreptitiously begins to sip from it.*)

SALOME: I was only saying.

DU PRE: Well, on credit then. We can pay tomorrow. With interest.

SALOME: But they always say no.

DU PRE: (*To SALOME.*) Keep your mouth shut, for God's
 sake! Lenie! See if there are any more candles!
 (*LENIE fumbles around in the skip. Everyone waits
 apprehensively.*)
 Stop looking at me! Why do you always look at me?
 Accusing me!

LENIE: Yes, there are. Two packs, Meneer.

DU PRE: And the torch to shine on Good Deeds at
 the end?

LENIE: It's here. (*She switches it on.*) It works!

DU PRE: Switch it off. You're wasting the batteries.

LENIE: Yes, Meneer. (*She switches it off.*)

ABEL: (*To SALOME.*) You see! You were worried for nothing!

SALOME: But that's not enough. We can't act in the dark.

DU PRE: Of course it's enough! It will create atmosphere!
 (*Theatrical.*) Remember *Everyman* takes place in the
 Middle Ages. (*He laughs.*) The Dark Ages.

SALOME: (*Giggling.*) Oh, Noekie! You're a scream.
 (*Suddenly she sees ANTOINE.*) Look! He's at it again!

ANTOINE: It's for the cold.

DU PRE: (*Roaring and storming up to him.*) Absolutely
 penniless, but never without booze! You sot! (*He grabs the
 half-jack and throws it violently on the ground.*) Only four
 actors! One is pregnant and another drinks like a fish!
 (*He sinks down on a step in front of the altar.*) It's all
 hopeless. All hopeless. (*He starts to cry softly.*)

SALOME: (*Sitting next to him, her arm around his shoulder.*)
 Don't cry, Noekie. Don't cry.

DU PRE: I'm tired. My God, I'm tired. I wish I had a gun,
 or poison so that I can make an end to it all. Or a sword.
 A sharp sword. That would be the best, yes. To fall onto
 a sword.
 (*ANTOINE stares at DU PRE, picks up the half-jack and
 screws on the cap. Sounds of a big dog barking and snarling
 viciously. The sound gets louder. Suddenly the church door
 opens and bangs against the wall. A woman dressed in black
 stands starkly silhouetted against the sharp, cold light. She
 carries a basket over her arm. The dog is still growling.*)

ANNA: (*Looking back. Loudly and imperiously.*) Quiet, Wolf!

(*She closes the heavy door loudly, then turns and looks at the company in silence. ABEL is visibly shocked.*)

DU PRE: (*Very formal.*) Good morning. Can we be of assistance?

ANNA: Allow me to introduce myself. My name is Anna. (*She smiles.*) Abel's wife.

DU PRE: Really?

ANTOINE: (*Sing-song.*) Abel. Your wife is here to see you. (*No reaction.*)
Abel!

DU PRE: This is certainly an unexpected twist.

ANNA: (*Coming closer, standing behind ABEL. Very friendly.*) My beloved husband. How long has it been? Two, no, three years. How time does fly.
(*ABEL turns his head slowly and looks at her.*)

ANNA: You look a little older. But quite well, as always. (*To the company.*) I know that you've been travelling all night, and I thought that you might need some refreshments, so I've taken the liberty of bringing you all something to eat.

SALOME: How sweet of you!

DU PRE: Very thoughtful.

ABEL: Why are you here? What do you want? (*Turning to DU PRE.*) Please Meneer, tell her to go! You don't know her. You don't know what she's like! (*To ANNA.*) I never wanted to see your face again!

ANTOINE: Temper, temper.

ANNA: (*Laughing.*) I thought I'd spoil Abel a little. I've brought all his favourite things. I hope you'll all like them. (*She takes off her heavy coat, beneath which she wears a simple black dress.*) Sjoe, there's quite a nip in the air this morning. Everything's covered in frost. (*Looking around her.*) Where shall I put the basket?

SALOME: Here on the table. Would that be alright, Mrs…Vermaak?

ABEL: Meneer! I beg you!

DU PRE: I thought you were hungry!

ANNA: Oh, just call me Anna. I'm part of the family after all…more or less. Perhaps the worst of the cold is over.

It is almost September. Shall I unpack, or would you
rather eat a little later?

DU PRE: Oh, no! We shall eat while you are with us, and
enjoy the meal together.

ANNA: Thank you. I'd like that. You are very kind. I haven't
seen my husband for such a long time.

ABEL: Don't call me that.

SALOME: The table is not very clean. (*Dusting it with a
costume.*) *Voilà!* That's better.

ANNA: (*To ABEL.*) Why ever not? (*To SALOME.*) The food
isn't hot, I'm afraid.

SALOME: That's nothing to worry about.

(*DU PRE, ANTOINE and SALOME go and stand next to
ANNA and watch her unpack. ABEL and LENIE stand
aside.*)

ANNA: Here's ginger beer, cold roast lamb, potato salad,
preserved quinces and milk tart.

SALOME: Oh, how marvellous!

ANTOINE: Gorgeous!

DU PRE: A veritable feast! You're an angel of mercy!

SALOME: Abel, Antoine, do fetch us some chairs. And dust
them off. Then we'll all eat together.

ABEL: (*To LENIE.*) Don't put her food in your mouth!

LENIE: I must eat.

ABEL: You mustn't!

LENIE: But think about our child. I can't go on like this.

(*LENIE looks at ABEL then she moves slowly to the table.
ANTOINE brings the chairs.*)

SALOME: Oh, where are my manners? Please forgive me.
My name is Salomé, and this is...

ANNA: Of course. The famous Dantie Du Preez. (*She uses
the Afrikaans pronunciation, not the affected French.*) I can't
think of anyone who wouldn't know him.

(*A loud scratching is heard on the church door.*)

Don't be alarmed. That's my dog. I had to get a big and
fierce dog after Abel left. I need protection from all the
starving wretches and marauders. (*She shouts commandingly
in the direction of the door.*) Quiet, Wolf and lie down!

(*Short silence.*)

DU PRE: And this is Antoine.

ANNA: Pleased to meet you.

> (*ABEL sits in a dark corner from where he watches ANNA with intense suspicion.*)

ANTOINE: Delighted. (*He kisses her hand.*)

ANNA: (*Coquettish.*) And Abel...who is the young lady? Do introduce us.

> (*ABEL turns away.*)
>
> (*With a small laugh.*) He can be so moody. But I know him.

ABEL: You don't know me!

ANNA: (*With feigned shock.*) My word! Well, I shall ask her myself. What's your name?

ABEL: Don't tell her. Don't tell her anything about yourself.

ANNA: Oh well, it doesn't matter. I'll have to guess. Well...let me think. (*She thinks.*) What about...Lenie? Is that right?

> (*LENIE nods. A sharp intake of breath from ABEL.*)
>
> So you're Lenie? Well, Lenie do sit down. Come and eat something. You look pale. (*She unpacks crockery and cutlery from the basket.*)

DU PRE: (*Applauding.*) Very impressive. You're quite a conjurer, dear Anna.

SALOME: Plates too! And glasses and knives and forks!

ANNA: Yes. (*She laughs.*) I'm a very thorough woman! Abel knows that. (*To SALOME.*) Do pass them around.

SALOME: Serviettes too!

ANNA: (*Laughing.*) But of course! Who is going to carve the joint? Abel was always so good at it.

DU PRE: Then Abel shall do so. (*Proudly.*) I'm not particularly good at that sort of thing. Two left hands, you know.

ANTOINE: I'm a bit clumsy too.

ANNA: My dear, it appears we are all relying on your skills.

ANTOINE: Yes! Come on, Man! We're hungry.

ANNA: (*Holding out a large carving knife, playfully.*) I hope you've not lost your touch.

(*ABEL starts busying himself with the props.*)

ANTOINE: What a bore. He's sulking.

SALOME: (*Looking at the serviette.*) Starched damask! I can't remember when last I saw that. We always ate like this as children.

ANNA: Is that so? Well, I'll have to do it myself. (*She starts carving. To the company.*) Potato salad anyone?

ANTOINE/SALOME/DU PRE: Yes, please.

ANNA: Help yourselves. And please pour your own ginger beer. I only have one pair of hands. My word, this place is cold.

SALOME: Isn't it just?

ANNA: Doubtless because of the thick walls and the broken windows.

DU PRE: The ginger beer is delicious! Heavenly.

(*SALOME shrieks and points at something on the table.*)

ANNA: (*Quickly removing a shoe, she takes it by the heel and smashes it down on the table.*) Dead! It must have come out of the basket. I really must apologise. It's really very embarrassing. (*She puts on her shoe.*)

DU PRE: (*Falsely.*) Not at all. Not at all.

SALOME: It's the biggest one I've ever seen.

ANNA: There's a plague of cockroaches and vermin in this town. It's the poverty and squalor these people live in. Can you imagine, I've had to put the legs of my brass bed into tins filled with paraffin. Otherwise terrible things would be crawling all over me while I was asleep. (*She finishes carving.*) Well, I think that should do. A nice young lamb. (*She sits down.*) Please, go ahead. I won't have anything.

ANTOINE: It looks delicious.

DU PRE: Delectable.

(*DU PRE, ANTOINE and SALOME all help themselves eagerly to the lamb.*)

SALOME: (*Little shriek. Pointing at ANTOINE.*) He stuck a fork into my hand!

ANNA: One at a time. There's quite enough for everyone.

DU PRE: (*Helping himself. To ANTOINE.*) Ladies first. Don't you have any manners?

(*SALOME and ANTOINE start eating ravenously.*)
I hope you will be so kind as to make people aware of our presence here. The performance is of the highest standard, I assure you.

ANNA: I will do what I can.

DU PRE: Will you really?

ANNA: (*Smiling.*) Yes, of course. (*She sighs.*) But I must warn you that things aren't going very well here at the moment.

DU PRE: I know. I'm afraid it's much the same all over the country. The Depression has hit very hard.

ANNA: Most people here live from hand to mouth. A sheep sells for a sixpence and they're almost giving chickens away. A lot of farmers have moved away to the cities. Packed up and gone with children and all. They just abandon their land, which a few rich farmers buy up for a song.

ABEL: Like your brothers. Those scavengers.

ANNA: That's true. Well, they were among those few with foresight who predicted exactly how the dice would fall. There are so many stray pets on the streets. I've taken a few in. (*Sweet smile.*) I'm so fond of animals. But besides that, what can one do? (*She sighs.*)

DU PRE: But our tickets aren't at all expensive. On the contrary. And it's so important to feed the soul.

ANNA: I know, I know. I couldn't agree more.

SALOME: Delectable potato salad. So piquant!

ANTOINE: The lamb just melts in the mouth.

ANNA: Thank you. (*To DU PRE.*) And there's another thing. There's a circus in town tonight.

DU PRE: I've seen the posters. Garish and vulgar. (*Upset.*) I didn't know it was tonight.

ANNA: There are many people who have saved up to see it. They're all too fond of circuses. Oh, yes. Nothing to eat, but there they'll be in the queue. (*She laughs.*) Not something I'd go hungry for, but each to his own.

DU PRE: 'Twas ever thus. The circus invariably precedes us. We will just have to act swiftly! Make ourselves visible, attract attention!

ANNA: Quite so.

DU PRE: May I propose a toast? (*He lifts his glass.*) To the good lady Anna! Our lucky charm!

ANTOINE/SALOME: To Anna.

ANNA: Ag, thank you. (*She laughs.*) Thank you.

> (*They eat in silence for a while.*)
>
> Oh, before I forget. (*She pulls the basket towards her and searches through it.*) I brought another little something. (*She takes out a white christening garment.*) For the little one. (*She gives the dress to LENIE.*)

LENIE: (*Taking it, uncertainly.*) Thank you.

> (*ABEL snatches the garment from LENIE and throws it on the skip.*)

ANNA: I made it myself. All done by hand. (*To ANTOINE.*) Excuse me, could I ask you to pass me the salt, please? (*To LENIE.*) I hope it's a boy. Every man needs his name kept alive. I'm so sorry I haven't given him a child. Not that we didn't try.

DU PRE: (*Wiping his mouth.*) This so reminds me of days gone by. Good food. Good company. Good conversation.

SALOME: Oh, that's so true!

DU PRE: Our company was of course much larger back then.

SALOME: We only performed in city halls. We always travelled first-class. Oh, and so many costumes. And two stage managers.

DU PRE: There was even a time when we had three.

SALOME: Yes, I remember.

DU PRE: And only city halls. Nothing less!

SALOME: And chock-a-block!

DU PRE: Crammed to capacity!

SALOME: No room for a mouse!

DU PRE: Before we went up, the house would be humming with expectation.

SALOME: There was always applause as the curtains opened. Our sets were so lovely.

DU PRE: Décor!

SALOME: Our décor! And we had everything. A machine you could turn to make wind-sounds. A steel sheet for thunder.

DU PRE: Even a smoke and fog machine!

SALOME: But not for very long.

DU PRE: For a year or two.

SALOME: No, Noekie. It was just a month or two. It was hard to find dry ice on the platteland.

DU PRE: That's right, I remember now.

SALOME: And at the curtain calls we were deafened by the cheering!

DU PRE: (*Shouting.*) Bravo!

SALOME/DU PRE: (*Applauding.*) Encore! Encore!

SALOME: (*Very excited.*) I remember one time, when we took twenty curtain calls! (*Bowing and blowing kisses to an imaginary audience.*)

DU PRE: And there were always receptions after the performances.

SALOME: With food like this. And wine. And the mayor with his gold chain always made a speech.

DU PRE: (*Playing a mayor.*) 'Ladies and gentlemen! May I have your attention, please ladies and gentlemen! (*Short pause.*) Thank you. We are indeed greatly honoured this evening to have Dante du Pré and his brilliant company in our midst.'

SALOME: (*Giggling.*) In little towns it was tea and cake.

DU PRE: Such enthusiasm! (*Gallantly.*) And how Salomé bewitched the men.

SALOME: (*Shyly.*) Oh, come on.

DU PRE: Those were the days. But it wasn't always like that. At least not to begin with.

ANNA: A little more meat?

DU PRE: Yes, thank you very much. (*While he talks, he holds out his plate and allows ANNA to serve him.*) A small company. There were just the five of us. We were so young and so romantic. (*He laughs.*) We put on tear-jerkers that had all the old ladies weeping in the aisles.

SALOME: I did too. I cried and cried. I sobbed until I thought my bones would break. (*Light laugh.*) And afterwards I went backstage. I was so excited. And so scared. (*She points at DU PRE.*) He was still in his costume. A cloak and hood.

DU PRE: (*Formal and self-important, as though looking down at someone much shorter than himself.*) And what can I do for you, young lady?

SALOME: (*In a high-pitched voice.*) Uh... I just wanted to come and say... I just wanted to ask...if you want me.

DU PRE: I don't understand, Miss. What do you mean?

SALOME: If you'll take me with you. Suddenly I just... I just know that the theatre is my life. And all I want to do is act and act and act.

DU PRE: Is that so?

SALOME: Oh yes!

DU PRE: And if you do not act and act and act, what then?

SALOME: (*Dramatically.*) Then I will die.

(*ANNA and ANTOINE laugh and applaud.*)

DU PRE: (*Laughing.*) And that's just the way it happened.

SALOME: Mamma and Pappa wouldn't hear of it. So I ran away. And I never looked back. (*Looks down and goes on eating.*)

ANNA: So the two of you have been working together for a long time?

DU PRE: From that moment on we worked together, yes.

ANNA: (*To ANTOINE.*) And when did you join?

ANTOINE: A few years ago. I was a music teacher. I was leading quite a quiet life, but what can I say? The theatre was in my blood. It left me no choice.

DU PRE: Oh yes. The theatre can be a deadly sickness. A raging fever.

ANNA: (*To LENIE.*) I suppose you were also dazzled into joining?

ABEL: (*To LENIE.*) Don't tell her anything about yourself.

SALOME: When she joined us she was such a poor, lost little thing. Just like a stray kitten.

ABEL: Don't tell her anything! It's none of her business!

SALOME: (*Offended.*) Excuse me!

ANNA: Don't mind him.

DU PRE: Fortunately she could act.

SALOME: Not very well as first. It's experience that counts.

ANNA: Oh well...has everyone had enough to eat?

ANTOINE/SALOME/DU PRE: (*Almost simultaneously.*) Yes, thank you. More than enough.

ANNA: Oh, before I forget. I'd like to invite you all for dinner. After the performance.

DU PRE: How very kind of you.

ANNA: Everything will be just like it used to be. The mayor, the gold chain, the toast and everything.

DU PRE: We are overwhelmed. Really, overwhelmed.

ANNA: There'll be a fire in every fireplace. The best red wine from my former late husband's cellar. Venison, pumpkin pie, sweet potatoes and koeksusters.

SALOME: I hope you're not putting yourself out on our account.

ANNA: Not at all. To tell the truth, it's already prepared. It is a sort of celebration dinner. Abel's homecoming!

ANTOINE: How appropriate.

ABEL: You won't see me there. I'd rather die!

ANTOINE: Temper, temper.

ABEL: Stay out of this!

ANNA: (*Laughing.*) Well, we shall see. (*She stands.*) I should be going.
(*SALOME begins to clear the table.*)
Oh no. Please just leave it all. I'll send the servants to collect everything later.

SALOME: You're too kind.

ANNA: There is something else. I have several guest rooms. With feather beds and down quilts. You're more than welcome to stay the night.

DU PRE: (*Formal.*) No. Thank you very much. You have been more than kind. We will get by.

SALOME: Noekie! (*To ANNA.*) He's so proud. (*To DU PRE.*) But, Noekie…just think!

ANTOINE: To be able to stretch out!

SALOME: To sleep all soft and warm.

ABEL: Mr Du Pré is right. Stay away from there.

SALOME: Come on, Noekie! A good night's sleep will do you the world of good.

ANNA: Listen to her, Noekie.

DU PRE: (*Roaring.*) My name is Dante du Pré!

ANNA: (*Affronted.*) I'm sorry. (*She puts on her coat with ANTOINE's help.*)

SALOME: We accept. We accept. Don't let him upset you.

ANTOINE: We are really grateful.

ANNA: (*Coolly.*) Good. I'll be off. (*She moves to the door.*)

SALOME: (*With a meaningful nod of her head.*) He's just a bit temperamental. Take no notice.
(*DU PRE ignores her.*)
We'll walk some of the way with you.

ANNA: That's not necessary.

SALOME: Oh, but we'd love to!

ANTOINE: Honestly!

SALOME: And perhaps if we meet anyone on the way, you could introduce us.

DU PRE: (*Suddenly friendly again.*) A wonderful idea. Where's my cloak?

SALOME: Here. You just threw it down in a heap.
(*DU PRE cloaks himself, takes a round mirror out of his shirt pocket and peers into it. ANTOINE, SALOME, ANNA and DU PRE then move to the door.*)

SALOME: (*Turning to look at ABEL and LENIE*) Aren't you coming?
(*There is a short silence.*)
Oh leave them. They're in a mood.

ANNA: (*Laughing.*) That's my Abel. (*To ABEL.*) See you later. (*To LENIE.*) You too, Lenie.

SALOME: Adieu!
(*The four leave. Their voices continue off stage. Sounds of a dog growling and snarling while SALOME gives a high-pitched scream.*)

ANNA: (*Off.*) Down, Wolf!
(*Dog sounds stop.*)
(*Off.*) He's really very obedient.

DU PRE: (*Off.*) Stop clinging to me!

ANTOINE: (*Off.*) Where to now?

ANNA: (*Distant. Off.*) Just here. Round the silo.

DU PRE: (*Distant.*) Not a bad little town, really.
(*ABEL goes to the door, looks out, and closes it. LENIE has picked up the christening dress and is looking at it.*)

ABEL: (*Urgently.*) Give it to me! Give it here! (*Takes the dress.*) You shouldn't touched it!

LENIE: (*Frightened.*) How did she know? How did she know about the baby? She frightens me.

ABEL: I told you about her. (*He looks at the dress.*) We've got to get rid of this. 'All done by hand'!
(*Distant sounds of blaring trumpets, whistles and drums – the circus parade – the parade sounds continue until otherwise indicated.*)

LENIE: Let's hide it away somewhere.

ABEL: No! Then it'll still be here! With us!

LENIE: Maybe we could just leave it here tomorrow.

ABEL: No! Tomorrow is too late.

LENIE: What do you want to do?

ABEL: Where's the paraffin can? Maybe there's still a bit of paraffin left. Where is it?

LENIE: Here. Here. (*She gives it to him.*) What are you going to do?

ABEL: Burn it! Burn it! There mustn't be anything left of it! Just ash. (*Excited.*) Look! We can burn it in the tin trunk. (*He drags the tin trunk closer and opens it.*) Empty it while I go and find the matches.
(*ABEL searches around hastily. LENIE unpacks clothes and throws them on the floor.*)
Yes! Here they are! (*He shakes the can of paraffin and opens it.*) Bring that thing over here.
(*LENIE picks up the dress.*)
Come on! What's wrong with you?

LENIE: I don't know.

ABEL: Listen to me! We must do this!
(*LENIE puts the dress in the trunk. ABEL throws the last few drops of paraffin over the dress.*)
Stand back. (*He throws a lit match into the trunk.*)
(*High flames leap up immediately. The two stand solemnly staring at the flames. The flow from the fire lights their faces. After a while LENIE moves to ABEL. He puts an arm around her shoulder.*)

LENIE: (*Curious.*) Why didn't you want me to tell her my name?

ABEL: I didn't want her to know anything about you.
(*ABEL takes LENIE in his arms and presses her head to his chest. The flames die down. After a moment they disappear.*)

When the trunk's cooled down I'll empty it outside.
Then it'll all be over.
(*Short silence.*)
You're shivering. Come and sit down for a bit.
(*He leads LENIE to a bench and they sit down. LENIE leans her head on ABEL's shoulder.*)

LENIE: I'm sorry I was angry with you. Now I know why you were scared of her. Every time she looked at me, my heart felt cold and small. (*Pause.*) Before I saw you, I didn't know anything. (*Urgently.*) Do you love me?

ABEL: Yes. Very much.

LENIE: Promise. Promise me.

ABEL: I promise.
(*Silence. He rocks her gently to and fro.*)

LENIE: (*Lifting her hair off her neck.*) I've got a tiny birthmark. Here. Just under my ear. Look.

ABEL: (*Touching the mark with his finger tip.*) I see it.

LENIE: There mustn't be anything of me that you haven't seen.
(*ABEL laughs softly.*)
What is it?

ABEL: (*Lifting her hair and kissing the mark.*) Your birthmark looks like a fat mosquito.
(*They laugh together.*)

LENIE: (*Suddenly uneasy.*) Hold me tighter.
(*ABEL holds her close.*)
Call me by my name. My whole name.

ABEL: (*Playfully.*) Magdalena, Susara, Johanna.

LENIE: (*Laughing.*) No, Johanna Susara.

ABEL: Magdalena, Johanna, Susara.

LENIE: Yes. That's right.
(*Silence.*)
We should never have come. We should never have come here.

ABEL: It's alright, it's alright. We'll leave early tomorrow morning. And the town will get smaller and smaller behind us.

LENIE: It's still so long to wait!

ABEL: Hush. Hush.

(*The parade sounds fade away completely. Silence.*)
Are you cold?

LENIE: Yes. Very cold. And my heart's beating very fast. Up here in my throat.

ABEL: Hush. I'm here.

LENIE: And will you always be with me?

ABEL: For ever and ever.
(*They laugh.*)
I used to pass this church every day on my way to school. It was abandoned then too. I looked in once. Through the holes in the windows.

LENIE: (*Seriously.*) And what did you see? Did you see the two of us? Is that what you saw? The two of us? (*Suddenly uneasy.*) Hold me tighter.
(*Voices outside.*)

DU PRE: (*Off.*) Well, there's one thing to be said of her: she knows every living soul in this town.
(*The door opens, DU PRE enters.*)

SALOME: (*Entering.*) It was very good being seen with her. *Mon Dieu*! The place is full of smoke! What happened? Was there a fire?

ABEL: Nothing serious. I was just burning rubbish.

DU PRE: (*Bellowing.*) Burning rubbish? Are you mad?

SALOME: (*Hysterical.*) And look! Look! In my trunk! It's black with all the ash and soot! And where are my clothes?

LENIE: There. On the table.

SALOME: Everything just chucked out! Even my underwear! No respect at all!

DU PRE: One can't turn one's back for a moment without all hell breaking loose! Where is Antoine? Where's he disappeared to now?

ABEL: (*Picking up the trunk.*) I'll empty it out and clean it up. (*He exits.*)

SALOME: (*To LENIE.*) And you pack my clothes back neatly, do you hear?

LENIE: Yes.
(*ANTOINE enters quickly.*)

DU PRE: And where were you? Creeping off for a quick one, I suppose?

ANTOINE: That's not true. I just got lost, that's all.

DU PRE: Lost!

(*ABEL enters with the trunk.*)

Imagine, we had to witness that revolting circus parade.

SALOME: Such vulgar people!

ANTOINE: A motley lot. And that cacophony! Completely out of tune.

SALOME: Did you see? The horses have mange. And those fat, half-naked people.

ANTOINE: Decidedly past their prime.

DU PRE: Grimaldi! With his moth-eaten moustache.

He knows what I think of him. Foreigner!

SALOME: That's right.

DU PRE: But still…the people were thronging to see them.

ANTOINE: Simpletons!

DU PRE: My God…to think that we have to compete with side-show freaks and sword-swallowers!

SALOME: And that Spanish lady on the horse…

ANTOINE: 'Spanish lady' my arse…

SALOME: I could see that she was wearing falsies.

DU PRE: If we want an audience tonight we'll have to do something. Make ourselves known. Anything to attract attention! You must all put on your first costumes. I shall make an announcement through the microphone as we walk through the streets!

(*As he speaks, ABEL wipes the inside of the trunk.*)

ANTOINE: We're not circus clowns! We are artists!

DU PRE: Do you want an audience tonight or would you rather die of starvation?

ANTOINE: But we've never done anything like that before. You usually just make a few announcements.

SALOME: And put photos in the shop windows.

DU PRE: There is no time for pride or idleness! Times have changed. Get dressed immediately!

SALOME: I refuse. I have admirers. A reputation! I do not parade around the streets in rags! To stoop so low! Have you no shame?

DU PRE: Admirers! You mad old woman. Nobody even knows who you are any more. Frills and flounces and

bows! It makes me sick! When last did you look in a mirror? Have you had a good look at yourself recently? You moulting old hen!

SALOME: (*Her face falls for a moment, then vehemently.*) And what about you? With your thinning hair that I have to paint black with a tooth brush? And your corset! All girdled up! To keep your flabby gut from hanging out! Pathetic! And your made-up face!

DU PRE: You're a bitch! A bitch!

SALOME: (*Through tears.*) Show them! Show them how handsome you look without your cheap false teeth.

ANTOINE: (*To SALOME.*) Stop it! What do you think you're doing?

(*There is a shocked silence.*)

DU PRE: (*Softly.*) He's right. This is hardly the time. Get dressed. Your brightest costumes. (*He sinks down onto a chair. Exhausted.*)

(*ANTOINE, ABEL and LENIE begin to look for costumes. SALOME stands on the spot. She looks smaller and pathetically withdrawn.*)

(*After a silence, lifts his head and looks at SALOME.*) Put something on. Something pretty.

SALOME: (*Tearful.*) I don't have anything to wear.

DU PRE: (*Turning his head away, he stands and begins to pace backwards and forwards.*) I'll walk in the front and make the announcements. You follow behind me, slow and stately. You will look at the public and smile slightly. (*He demonstrates.*) Not over friendly. Not too eager. And you're not to wave, do you understand? (*He swathes himself in God's robe, and notices LENIE.*) No, no, no, not that! (*He rummages for a dress with a low neckline.*) This one. They must be able to see you properly. And wear your hair loose. Let it hang over your shoulders. Pretty girls always attract plenty of attention.

LENIE: But I'll get cold.

ABEL: Yes, she will, Meneer.

DU PRE: It's just for a few hours! Is that so much to ask? (*He puts on God's shining crown. To ABEL.*) What about a sword? It would be impressive.

(*LENIE puts the dress on.*)

ABEL: The point's broken.

DU PRE: No one will notice. (*He looks at SALOME who is still standing rooted to the spot.*) You're going to be late.

SALOME: (*In a taut voice.*) I don't want anyone to see me. I don't want anyone to look at me.

DU PRE: (*Going to her and putting his arm around her shoulders.*) You're very pretty from a distance. On stage you look as young as ever. (*He strokes her cheek gently with his forefinger.*) And that's what it's all about, isn't it? Illusion.

(*SALOME looks up at him.*)

Today we're old and tired. And tonight we will be flushed with youth again.

SALOME: (*Small smile.*) Yes.

DU PRE: Well, go and get dressed. Put on one of the ones I like.

(*LENIE groans with pain.*)

ABEL: What's wrong?

LENIE: (*Another groan. She holds her stomach.*) A pain. Like a knife!

ABEL: Lenie. Lenie. It's alright.

LENIE: I think it's the baby.

ABEL: Ssh. Ssh. Come. (*He helps her to a bench.*) Just lie down.

(*LENIE lies down.*)

ANTOINE: It's probably just stomach ache. If you're hungry and you eat all of a sudden...

(*LENIE draws her legs up and shrieks with pain.*)

ABEL: We must call a doctor, Meneer!

ANTOINE: And what are we supposed to pay him with?

ABEL: I don't care! Lenie is very ill.

DU PRE: Let's wait and see how things go. Perhaps a little rest will solve the problem.

SALOME: I know about this sort of thing. My father was a doctor. If it's to do with a baby, there's only one thing to be done. She must lie still with her legs up. (*She takes a costume, bundles it up and puts it carefully under LENIE's head.*) There we go. (*She takes a big bundle of costumes. To ABEL.*) Lift up her legs.

(*ABEL lifts LENIE's legs and SALOME places the bundle under them.*)
That's right. And now you must try to relax. Sleep a bit. And then everything will be right as rain. And stay warm. (*SALOME gets a bundle of old costumes and puts them on top of LENIE. LENIE groans.*)
Just lie still. You should feel better in a moment. (*She begins hurriedly searching for a costume.*)
(*LENIE moans.*)

ABEL: I'm staying here, Meneer.

LENIE: Yes. Don't go away.

DU PRE: It's out of the question! You're a good-looking young man. You'll get all the young ladies' attention. You simply have to come. It's crucial.

ABEL: I'm staying here.

SALOME: See. She looks better already.

DU PRE: The pain's not so bad now, is it?

LENIE: (*To ABEL.*) Stay with me.

DU PRE: Come along, everyone. We'll wait outside. (*To ABEL.*) You stay with her for a while. See if you can calm her down. We need you, Abel. We need you with us. (*To ANTOINE.*) And you play your flute. Something slow. Something wistful. (*To ABEL.*) She only needs to sleep a little. She'll wake up quite refreshed.

ANTOINE: No! I won't do it. Walking through the streets and playing! No! I have a licentiate in music!

DU PRE: You will do it! At least it's something you can do! (*Clapping his hands.*) Come now, there's no time to be lost. (*ANTOINE mutters but gets his flute out.*)

SALOME: And don't forget the photo for the bookshop window.

DU PRE: (*To ABEL.*) See you shortly. (*To LENIE.*) Speedy recovery, Lenie.

SALOME: Just lie still, you hear. Adieu!
(*DU PRE, ANTOINE and SALOME exit. ABEL goes to LENIE and crouches next to her. He stokes her hair.*)

LENIE: I don't want to lose him. (*Cries.*)

ABEL: Ssh. Ssh. You won't. (*He puts his ear to her stomach.*) There's nothing wrong with him. He's happy as can be.

LENIE: It's her. Your wife. She's cursed me.

ABEL: No. You're imagining things. Everything's alright.
Everything's going to be fine. Ssh.

(*While the scene between ABEL and LENIE continues,
ANTOINE can be heard off-stage, playing a melancholy tune
on his flute while DU PRE, his voice slightly distorted by the
megaphone can be heard making a dramatic announcement.
He repeats the same announcement.*)

DU PRE: Ladies and gentlemen, tonight at eight o'clock in
the old Catholic church, Dante du Pré's celebrated
company proudly presents the timeless and inspiring tale
of *Everyman.*

(*The voice and music become fainter as the actors move
further off.*)

LENIE: Kiss me.

(*ABEL kisses her.*)

Hold my hand.

(*He does so.*)

I wish we could go. Right now.

ABEL: Tomorrow morning.

LENIE: Tell me about tomorrow morning.

ABEL: (*As if telling a story.*) We'll sleep here alone tonight.
We'll make a soft bed out of all the costumes. The two of
us close together, covered in silk and velvet till the sun
comes up. We'll pack and then we'll get dressed. I'll wear
my jacket and you'll wear your coat. I'll carry our bags
to the station. And we'll wait for the first train. There it
comes, all noisy and blowing clouds of smoke. We'll
stand at the window, and the train will jerk and start
to move.

(*LENIE sighs with happiness.*)

Slowly at first, and then faster and faster. And then we're
out of town. We look back. We see the church steeple, the
silo, the houses where people are still sleeping and the
frost like snow on the roofs. The town gets smaller and
smaller and smaller, until it disappears completely. And
all we see then is the open veld and the sun rising over
it. (*He kisses LENIE on the forehead.*) Sleep a little. (*Stands*

up softly.) You're very tired. (*He sheathes his sword and smiles at LENIE.*) I'll be back soon. You'll see. (*He moves to the door.*)

LENIE: Please, just tell me again. And then you can go. (*ABEL sits down next to her.*)

Hold my hand. I feel so light. I feel as if I'm flying away.

ABEL: (*Taking her hand.*) No, you're here. With me.

LENIE: Tell me about tomorrow. When we leave this place.

ABEL: We'll get on the early train. We'll stand at the window. I'll have my arm around you. And then...

LENIE: Whisper it to me... In my ear... I want to feel your breath...

(*ABEL whispers in LENIE's ear. ANTOINE's music and DU PRE's announcement can still be heard in the distance. ABEL stops whispering and looks at LENIE who appears to be asleep. He kisses her softly on the cheek and gets up. He moves towards the door. At the door he turns and looks at LENIE before he exits rapidly.*)

LENIE: (*Murmuring.*) Abel... Abel...

(*The lights fade slowly to black.*)

End of Act One.

ACT TWO

Pale beams of sunlight fall through the high windows. Parts of the church look cold and dark, while others are bathed in the light. Some rays catch LENIE's face as she lies quite still on the bench. There is a small pool of blood beside her on the floor. DU PRE and SALOME enter. They are breathless and look exhausted. SALOME is holding DU PRE's arm.

DU PRE: Let go of me! Leave me alone!

SALOME: I'm only trying to help. Don't be horrible to me.

DU PRE: There's nothing wrong with me. Always fussing like an old hen. Why did you have to drag me away like that? Abel won't be able to make a proper announcement.

SALOME: (*Indicating a bench.*) Sit down, Noekie.

(*DU PRE sits. He closes his eyes.*)

What's wrong now?

DU PRE: Nothing's wrong, for God's sake! Stop staring at me with your little beady eyes.

SALOME: (*Taking off her shoes.*) Look at my poor bunions. Red and swollen. And I feel quite dizzy. Why did we have to walk so far? We've been walking for more than an hour.

(*DU PRE puts his hand over his eyes.*)

What is it?

DU PRE: Nothing. Sunspots. Coming out of the light into this place.

SALOME: It's gloomy, isn't it? Smells musty. Ugh.

DU PRE: Did you have to start wailing like that in the main street?

SALOME: When you fainted, I thought you were dead. I was so scared. (*Little sob.*)

DU PRE: You know I've been getting these spells. It's nothing.

SALOME: You should go and see a doctor. (*She points.*) Look...your dye is running.

DU PRE: Where?

146

SALOME: Must be the heat. (*Takes a small handkerchief out of her sleeve.*) A small line down the middle of your forehead.

DU PRE: God, I must look a fright.

SALOME: (*Wiping off the dye.*) I'm sure no one noticed. All gone.

DU PRE: Give me my mirror. Let me see.
(*SALOME gets the mirror.*)
(*DU PRE looks into the mirror.*) God I look awful.

SALOME: You need a nice, hot bath. That's all. (*She strokes his hair.*)

DU PRE: Stop fussing!

SALOME: Shhh. Lenie's still sleeping. I hope she feels better. What a bunch of bumpkins. No one even asked for my autograph.

DU PRE: Miserable creatures. What do they know about art? What do they care? Oh… I'm tired… I'm tired.

SALOME: A lot of people looked at us.

DU PRE: You mean gaped at us. Idiots!

SALOME: (*Looking at LENIE.*) My father used to say that sleep is the best medicine. Poor little thing. Sometimes I feel so sorry for her that I get tears in my eyes when I look at her. But you know what I'm like. I'm very tender-hearted. Noekie…look.

DU PRE: What is it now?

SALOME: There…under the bench. It looks like blood. It is blood!

DU PRE: Let me see. (*He gets up and moves closer.*) It is blood. Real blood.

SALOME: And why is she lying so still? Tell her to wake up!

DU PRE: (*Imperious.*) Lenie, wake up! I say, wake up Lenie! (*Uncertain.*) Time to wake up, Lenie. Come now, Lenie…

SALOME: She's not waking up! Noekie, she's not waking up. You must shake her.

DU PRE: Yes. (*He shakes her.*) Wake up now Lenie. (*He backs off.*) She feels so…cold. Maybe she's only fainted. Of course, there's one way to tell for certain…

SALOME: And what's that?

DU PRE: Hold a mirror in front of her mouth and nose. If it doesn't cloud up...that means she's not breathing.

SALOME: (*Quietly. Horrified.*) Not...breathing...

DU PRE: Pass me the mirror.

SALOME: (*Giving him the mirror.*) I can't bear it. I won't look. (*She turns her back and puts her hands over her eyes.*) What do you see?

DU PRE: I haven't done it yet. (*He puts the mirror close to LENIE's mouth.*)

(*Small whimpering sounds from SALOME in the silence.*)

SALOME: And now?

DU PRE: (*Looking at the mirror.*) Nothing...

SALOME: What do you mean?

DU PRE: She dead, that's what I mean! My God... What a thing to happen... So much dying on the stage, but when it really happened, there was no one watching. (*He gives a laugh that sounds like a sob.*)

SALOME: Yes... (*Brokenly.*) She was alone... All alone. (*Through her tears.*) We should have called a doctor! Then she'd still be alive. But you were too mean!

DU PRE: Not now, for God's sake!

SALOME: She was too weak. She's been more than fragile for two years now. Tired. Drained. Never slept in a warm bed. Always too hot or too cold. This is no kind of life for anyone. Not even for a dog.

DU PRE: (*Softly, bitterly.*) So that's what you think? Well, this is my life. And it's your life. It has been for forty years. Now suddenly, it's not good enough.

SALOME: It wasn't always like this. It was different before the Depression. (*Weeping.*) How could I ever have thought...

DU PRE: I see. So this is the limit of your dedication. (*Suddenly loud.*) You don't know the meaning of the word! (*He darts a glance at LENIE. Short silence.*) It means for ever and always. Through thick and thin.

SALOME: I'm here, aren't I?

DU PRE: Where else would you be?

SALOME: I could have gone home.

DU PRE: Home?

SALOME: Yes! To my mother and father.

DU PRE: Home! They said: 'Choose. Choose. And if you go, don't every come back.'

SALOME: I should have stayed at home! (*He sniffs.*) I should have listened to them. I broke their hearts.

DU PRE: It's too late for that. Far too late. (*Short silence.*) Don't cry.

SALOME: (*After a pause. Looking at DU PRE.*) In every town we visit, I look for a corner house. A white house with a red roof. Because my mother is inside it. She sits in front of her mirror and plaits her hair. There are dahlias in a glass vase next to her bed. Big, pink dahlias with bright green stems under the water. My father's not there, but he'll be back soon. He was called out to a farm. He'll come in through the side door, carrying his brown leather doctor's bag and he'll say, 'A fine, healthy boy. About nine pounds.' (*Looking down at her hands.*) (*Flute music and ABEL's voice can be heard approaching. ABEL's voice is slightly distorted by the megaphone.*)

ABEL: (*Off.*) Ladies and gentlemen, we will be performing *Everyman* at eight o'clock tonight in the old Catholic Church.

SALOME: There's Abel now. I feel like running away. I can't stay here... I really can't...

DU PRE: How will I be able to tell him? What should I say? (*Muttering as he rehearses what to say.*) Abel, my dear friend... I have some extremely tragic news... No. I won't be able to. It's not something I know how to do. I've never done it before.

SALOME: I know! Let's pretend to be asleep...pretend that we haven't noticed anything. Then he can find out for himself.

DU PRE: Yes...it's better that way.

ABEL: (*Off. Now very close.*) Ladies and gentlemen, we will be performing *Everyman* at eight o'clock tonight in the old Catholic Church.

SALOME: Come on...we have to be quick. We must sit down here and then we lean against each other and close our eyes. (*She sits down on a bench and pulls DU PRE down next to her.*)

DU PRE: Yes...yes. We must do that. My God. Poor Lenie.
 (*They lean against each other and close their eyes very tightly.*
 ABEL and ANTOINE enter.)
ANTOINE: I've got blisters on my lips from all
 that blowing.
 (*DU PRE starts snoring slowly and rhythmically.*)
 And they couldn't even appreciate it. A bunch of
 ignoramuses. (*He sees DU PRE and SALOME.*) Look,
 they're asleep. They really are past it, poor dears.
ABEL: Lenie's still asleep. I hope she's much better.
 (*SALOME whimpers.*)
 She's sleeping so quietly.
ANTOINE: It'll do her the world of good. I've never seen
 so many repulsively ugly people in one town.
ABEL: I won't wake her up. Yes. Let her sleep for a little
 bit longer.
 (*Stifled sob from SALOME.*)
ANTOINE: And the deformities. They don't need a freak
 show in this town. They should ask an entrance fee.
 (*Looking at DU PRE.*) And how pathetic he is. Making
 an announcement in that flowery language. (*He imitates
 DU PRE.*) 'The quivering voice and the melodramatic
 declamation.' He's completely out of touch, poor old
 has-been.
DU PRE: (*Opening his eyes.*) Vermin! How dare you!
ANTOINE: (*Confused.*) I'm sorry...
DU PRE: Pointing a finger at me! Calling me pathetic! You
 poor, shrivelled, repressed little runt!
ANTOINE: I really didn't mean anything by it... I was
 only saying...
ABEL: What's that?
DU PRE: (*Playing the innocent.*) What's what?
ABEL: There...under the bench...it looks like blood.
DU PRE: I have no idea. I don't know anything about it.
ANTOINE: Yes...I think it is blood.
 (*SALOME cries quietly.*)
ABEL: Lenie! Lenie! She's not waking up.
 (*ABEL seems paralysed with horror.*
 ANTOINE moves to LENIE.)

ANTOINE: (*Touching her gingerly.*) She's not breathing and she's cold as ice.

ABEL: (*Retreating.*) Cold…

DU PRE: (*To ANTOINE.*) Feel her pulse you idiot!
(*ANTOINE feels her pulse. After a time he shakes his head. ABEL moves slowly towards LENIE again. He puts his hand out to touch her face, but then he draws back. He starts shaking his head slowly.*)

ABEL: (*Softly.*) She did this… It's her… I know her. (*To DU PRE.*) I said she should leave. I asked you to send her away. I asked you, but you didn't. (*Louder. Becoming very agitated.*) I told you not to eat her food. To have nothing to do with her. You wouldn't listen! (*He points at LENIE.*) Do you see what you've done? (*Shouting.*) Do you see!?

ANTOINE: Stop it! How can you talk to him like that?

DU PRE: Leave him. Let him say what he wants to say.

ANTOINE: (*Confronting ABEL.*) And who is this woman? This terrible woman? Your wife, that's who she is! And now it's suddenly his fault! Did you tell Lenie about your wife when you seduced her, the poor innocent thing? No, you did not! You deceived her! You are a liar and a coward!

DU PRE: For God's sake, Antoine!

ANTOINE: I was kind enough to warn her. But still…the shock. To find out that you have a wife…and then to see her in the flesh. (*Pointing at DU PRE.*) And you blame him!

DU PRE: Stop it! What is the point? This terrible thing has happened. What is the use of blaming each other!

SALOME: That's right. It only makes it worse.
(*ABEL stumbles to the back of the church. He sits down on a bench, puts his face in his hands and sobs bitterly. ANTOINE drinks from his flask.*)

SALOME: (*Pointing to ANTOINE.*) Look!

DU PRE: Leave him. Antoine, do you mind if I have a drop or two?

ANTOINE: (*Eager and relieved.*) Of course not. You can drink it all.

DU PRE: Thank you. (*He sits down and drinks deeply.*)

ANTOINE: It's very good for shock. Maybe Abel needs some too.

DU PRE: (*He empties the flask.*) I really needed that.

SALOME: And what are we going to do now? (*Weeping.*) What…are we going to do?

DU PRE: Quiet. I'm thinking.

(*Silence as they watch him thinking. He gets up and starts moving around with a very intense expression on his face. ABEL can still be heard sobbing quietly.*)

ANTOINE: We have to tell somebody.

DU PRE: Not so hasty. We can afford to wait a while.

SALOME: Wait for what?

DU PRE: Keep it all quiet for a little longer.

SALOME: Keep it quiet?

DU PRE: How can you say that? People misunderstand things so easily. A young girl. Unmarried. You know what I mean. This is a small, conservative community and…well, it would be a scandal. We'd be hounded out of town. And what on earth would we do then?

ANTOINE: That's right. We haven't got a penny to buy a train ticket!

DU PRE: That's enough. Shut your mouth. (*He thinks.*) We could always ask Anna for a loan. With interest.

ABEL: No! You'll ask her for nothing!

DU PRE: Well, then there is only one possible course of action.

SALOME: And what is that?

DU PRE: We give the performance. And no one need know anything about this.

ANTOINE: How do you propose we do that?

DU PRE: (*He thinks for a moment, then excitedly.*) We hide her.

SALOME: What?

DU PRE: Yes. We take all the costumes out and hide her in the skip.

ABEL: What?

SALOME: *Mon Dieu*!

ANTOINE: (*Softly.*) A body in a basket. Like a bloody third-rate thriller.

DU PRE: You saw all those people staring at us. Tonight we give a show. And tomorrow morning we ride out of here first-class!

SALOME: And what about her?

DU PRE: We take her with us. In the skip.

ABEL: In a basket?

DU PRE: What else are we to do? If we can't borrow money, we'll have to creep away, and just leave everything. Her too!

ABEL: No! She can't stay behind! I promised her.

DU PRE: Well, what do you propose?

(*Silence. ABEL's head sinks.*)

Listen! Tomorrow we take her back to her town and bury her properly. Everyone will come from miles around. Flowers, candles, and I'll recite in the church. 'Skoppensboer'. Or no, no, 'This world is not a home to us'. (*Begins to recite.*) 'This world is not a home to us. The blood-red moon begins to glow through the veld dust, and I know as it bleeds on the church roof, where an owl roosts, mute with mystery, staring at the sky, aloof: This world is not a home to us.' (*To ABEL.*) Where is her home town? Is it near here?

ABEL: I don't know where she came from.

SALOME: But didn't she tell you?

ABEL: No!

DU PRE: Does anyone else know?

(*ANTOINE and SALOME shake their heads.*)

DU PRE: Confound it. She must come from somewhere.

ABEL: But where did you find her, sir?

DU PRE: At a station. She was in a train. Her hands were pressed against the window pane. (*Lifts his hands, palms forwards, and holds them on either side of his face. Short silence. He lets his hands drop slowly.*) She was dressed in black and her little face was pale and sad. And those big, tragic eyes.

SALOME: Yes, we felt so sorry for her. I cried because I felt so sorry for her.

ANTOINE: She said she was coming back from a funeral. Said she had no one left in the world.

SALOME: And nowhere to go.

DU PRE: So we said she could come with us.

SALOME: We thought she could sew on buttons…
Make tea…

DU PRE: And then we found she had talent. A natural, god-given talent. (*To ABEL.*) And she never spoke of her family or her birthplace? After all, you knew her better than any of us.

ABEL: She told me a lot. But she never mentioned names.

SALOME: How strange.

DU PRE: Oh well, it doesn't matter. We can bury her in the first pretty town we come across. One with a river and willow trees. How about that?
(*ABEL nods.*)
Good. Let's begin. Salomé, empty the skip.
(*SALOME starts throwing bundles of costumes out of the skip.*)

DU PRE: (*To ABEL.*) What shall we do? Should Antoine and I carry her?

ANTOINE: No! Not me!
(*ABEL doesn't answer. He picks LENIE up carefully. He tries to put her into the skip.*)

ABEL: What do we do now, sir? The basket's too small.

DU PRE: She must fit in!

SALOME: Here. Let me help. Bend her legs.
(*ABEL tries again.*)
That's it! Push her down a little. Yes. Now bend her arm. There we go.
(*ABEL stands next to the skip and looks down at LENIE. Slowly, he closes the lid. He stands motionless beside the skip.*)

DU PRE: (*Clapping his hands.*) To work! To work! It's far better for us to be occupied. Fortunately we are not short of things to do. There are all the preparations for tonight to think of. (*On the 'stage'.*) Without Lenie there is a great emptiness, not just because she was such a lovely human being, which she was…but because she had two very important roles in *Everyman*.

ANTOINE: We could learn the parts.

SALOME: Yes, we could.

ANTOINE: I'll play Death.

SALOME: And I can play Good Deeds.

DU PRE: Impossible. With there being so few of us you're already playing far too many roles. The audience will get tired of seeing the same faces again and again.

ANTOINE: My face, you mean! Why don't you just say it?

DU PRE: (*To ANTOINE.*) Knowledge, Confession, Senses, Power, Nephew, Doctor! That's enough! (*To SALOME.*) Beauty, Possessions, Family, Justice and Angel!

ANTOINE: Oh, I see. So he gets to play them! (*Pointing at ABEL.*)

DU PRE: No. Everyman can only play Everyman. (*Slapping his chest.*) And God can only play God!

ANTOINE: (*Sarcastic.*) Excuse me.

SALOME: Alright. So what do we do? Just cut them?

DU PRE: Don't be ridiculous! They are important parts. There must be somebody in town who could stand in.

SALOME: Do you honestly think that there's an actor or an actress lurking in every long-drop lavatory?

DU PRE: Of course not. Of course not. We will just have to make the best of the situation. We must find someone who can speak loudly and clearly, and can remember lines. They give concerts in every little town. There must be someone here who performs in concerts.

ANTOINE: Maybe some amateur who can recite? Is that what you mean?

DU PRE: I'd watch what I was saying if I were you.

ANTOINE: What do you mean?

DU PRE: Let's just leave it there, shall we.

ANTOINE: No, I want to know! I've had enough of this.

DU PRE: Shut your mouth, you boring little drunk.

ANTOINE: If I'm a drunk, it is thanks to you! I was quiet and respectable and never drank! I used to play the piano and the flute. And then I met you! With your red velvet cloak and your crown and your voice! And I thought that my life had just begun. But look at what has become of my life: I have the pleasure of being abused and publicly

humiliated by a pompous old man. Playing meaningless parts, travelling in cattle-trucks. Loading. Unloading. Doing all the dirty work! I'm sick of it. Sick to death! To hell with the lot of you! Antoine du Toit is his own man from now on!

DU PRE: (*Cold and sarcastic.*) No doubt you remember how we met, du Toit? In my dressing room. There were tears in your eyes. 'Take me with you,' you said. 'Take me with you.' You pleaded. You fell on your knees. You crawled in front of me. Writhing. Like a worm. 'I'll do anything. I'll sweep the stage. Just don't send me away.' Your face was wet with snot and tears and you begged, and yet now you want to be your own man? Remember this: You are a crawling insect. Nothing more! You disgust me! Get out! Get out of my sight! I never wish to set eyes on you again. Vermin!

ANTOINE: I will! You'll see! I'll go.

DU PRE: And another thing…you never wash! You smell like a skunk!

(*ANTOINE puts on his jacket, there is silence as the company watch him. He picks up his suitcase and walks slowly to the door. Just before he reaches it, he puts down his suitcase and drops his head. He starts to cry softly.*)

SALOME: (*Crossing to him and putting her arms around his shoulders.*) There, there.

(*ANTOINE, still crying, wipes his nose with his forearm.*)

Just tell him you're sorry. Go on. Tell him.

ANTOINE: I won't.

SALOME: Go on. Then it'll all be over.

DU PRE: I thought I told you to go. What are you waiting for?

ANTOINE: (*Soft and quiet.*) I'm sorry. Please forgive me.

DU PRE: What? Speak up, man! (*Sarcastic.*) You're not on stage now.

ANTOINE: I'm sorry! Please forgive me!

DU PRE: You revolt me!

ANTOINE: (*Sinking to his knees.*) Don't send me away! Please, let me stay!

(*DU PRE looks at him. Silence. He then looks away.*)

DU PRE: (*Softly.*) Come, stand up.
(*Silence while ANTOINE stands up slowly and dusts off his knees with his hands.*)
(*Suddenly business-like, as though nothing had happened.*)
You lot go and find someone who can do this show, and don't come back until you've found them. And hurry! What are you standing about for? I've told you what to do! (*To ANTOINE.*) And for God's sake, use your handkerchief.
(*ANTOINE wipes his nose on his sleeve.*)

SALOME: (*Softly.*) Let's go.
(*ANTOINE and SALOME exit quickly. DU PRE stumbles to a chair and sinks down at the table. He is obviously exhausted. ABEL stands motionless beside the skip. DU PRE picks up his little mirror and examines his features. Then he lifts the mirror, looks at the reflection of his middle-parting, and pats the loose skin of his jowls with the back of his hand. He looks up and sees ABEL, stands slowly and moves to him. He puts his arm around ABEL's shoulders. They move to the 'stage'.*)

DU PRE: My dear friend, believe me when I say that I feel your pain. Fate can be cruel. And pain lacerates the heart. Only time will heal this terrible wound. But in your grief, try and remember this: we are the servants of a sacred art. (*On the stairs of the 'stage'.*) No matter how great our sorrow, it is small in comparison with that of Phaedra, Medea or Oedipus. (*On the 'stage'.*) Agamemnon has been dying for centuries. Every day, he is murdered. Over and over and over again. And like an avenging angel, Cassandra still waits for his anguished cries. For hundreds of years, Hamlet has been betrayed, winged to rest by a poisoned sword. (*Turning back to ABEL.*) That is the Truth...and everything here is...ephemeral...
(*Slowly, ABEL lifts his head and looks at DU PRE. Suddenly the door opens. ANNA stands there. Instead of the simple dress she was wearing previously, she is now dressed in an elegant black dress, long gloves, and a little black hat with a net veil. ABEL stifles a cry, and turns away from her. ANNA enters, followed by SALOME and ANTOINE.*)

DU PRE: Good morning, madam. This is a surprise.

SALOME: You'll never guess! We bumped into her just across the road!

ANNA: I was on my way to invite you all for tea. (*Loudly through the half-open door.*) Lie down, Wolf! And be quiet! (*She closes the door.*)

ABEL: (*Urgently.*) Tell her to go!

DU PRE: I'm very sorry, madam, but we certainly don't have time for such luxuries. Antoine and Salomé were just searching for a replacement actor. (*Quickly.*) Our lovely Lenie had to leave us at very short notice.

ANNA: Really?

DU PRE: Yes. It was very sudden.

SALOME: But this is her, Noekie! It's her!

DU PRE: What are you talking about?

SALOME: I asked her who in the town could act, and she said that she could. She performs in every concert.

ABEL: What are you trying to do? You've never performed before. Never!

ANNA: Abel, my dear, a lot can change in three years.

DU PRE: (*Appraising her.*) Well, I did have someone a little younger in mind.

ANNA: (*Affronted.*) Well, in that case...

DU PRE: No, no, wait. You are very striking. And that is ultimately more important.

ABEL: She's lying, Meneer. She can't act.

DU PRE: Quiet!

SALOME: So rude.

DU PRE: Could you perhaps give me some idea of what you've performed recently?

ANNA: Certainly. For the last concert, I recited 'Sannie's Boots', 'The Concentration Camp' and 'Forgive and Forget'.

DU PRE: I see.

ABEL: Believe me! You have to believe me! It's some or other scheme of hers.

ANNA: What's the matter, Abel? Are you feeling ill? You're pale as death.

ABEL: Stay away from me!

ANNA: Of course.

DU PRE: Text, Antoine.

(*ANTOINE begins rummaging through the costumes.*)

ANNA: (*Uncertain.*) I must say, I'm a little nervous of reading in front of people like yourselves. Professionals. I mean I just do little concerts.

(*ANTOINE gives ANNA a battered script.*)

SALOME: Ag, don't worry about it!

ANTOINE: We aren't expecting much anyway.

ABEL: Now you'll see!

DU PRE: Go and stand up there. In front of the altar.

ANNA: (*Doing as she is told, looking at the script.*) Where should I begin?

DU PRE: Read the part of Death. Start at the top of page six.

ANNA: (*Clearing her throat.*) Wait a moment. May I take off my hat?

DU PRE: Please do.

(*ANNA takes her hat off and puts it on the table. Nervously, she runs her hands over her hair.*)

Please go on.

ANNA: (*Very soft and hesitant.*) 'Lord and Master, I will wander all the world…'

DU PRE: Speak up, please.

ANNA: (*Slightly louder, but still very unconfident.*) 'Merciless and cold, I seek until I find.'

ABEL: See? I told you!

DU PRE: Oh, no! Remember you're Death! You are omnipotent and majestic. Not some platteland housewife!

ABEL: It's over! You've had your chance. Tell her, Meneer.

ANNA: No. Wait. Let me try again. Just once.

DU PRE: (*Courteously.*) Of course.

SALOME: Just relax, *mon cherie.* Don't think about us.

ANNA: If you don't mind me asking, would it be possible to have a costume to wear?

DU PRE: I doubt whether it'll be of much help to you. But feel free to try. Antoine, get Death's costume for Anna.

ABEL: No! It's Lenie's!

DU PRE: Calm down! (*To ANNA.*) Come, put it on and then you can try again.

(ANTOINE gives ANNA the cloak and mask. Everyone watches as she puts on Death's long, flowing black cape and mask. She has some difficulty with the mask.)

SALOME: Hang on, let me help you.

ABEL: Lenie's clothes.

ANNA: Why should that upset you? I'm just trying to help. She's left you in the lurch, hasn't she?

DU PRE: Come, come. Please begin.

(ANNA stands in front of the altar. She turns to the front. The first few words are insecure.)

ANNA: 'Lord and master, I shall wander all the world...'

DU PRE: Thank you. That's quite enough.

ANNA: Please. Let me try again.

(Silence. She turns her back to them. Then she looks at the text for a few minutes, and puts it back on the altar. She turns slowly to the front, and stretches out her arms at her sides. The cloak spreads out like great, black bat's wings. She begins to speak in a deep, clear voice. She plays her role with complete commitment.)

(Terrifying and merciless.) 'Lord and master, I shall wander all the world. Merciless and cold, I seek until I find. I shall stalk every man who lives in sin, and heeds you not. I shall pierce him with my sharp sting! I shall blind him! I shall damn him to hell fire! For all eternity! Look there. *(She points.)* Everyman comes. But he knows me not. He has forgotten me. He thinks only of the lusts of the flesh. Of earthly things! *(She lifts her arms slowly above her head.)* What torture must wrack him as he stands before Righteousness!' *(Pause. She slowly drops her arms. There is a moment of astonished silence.)*

DU PRE: Bravo! Bravo!

(ANTOINE, SALOME and DU PRE clap and shout 'bravo'.)

SALOME: *(High and almost hysterical.)* Breathtaking!

ANTOINE: Outstanding!

ABEL: *(Anguished.)* What's going on? There's something wrong! Please! Please! You have to believe me!

DU PRE: That's quite enough!

ANNA: I just tried to do my best.

ABEL: This is impossible

DU PRE: I'm warning you! (*To ANNA.*) You have an exceptional talent. To think it has taken us to discover it.

ANNA: Thanks so much.

DU PRE: Now that we've found you, tonight is going to be an unmitigated triumph! Dear Anna, I beg you to join us. You dare not allow a talent like yours go to waste. With you in our company we will reach new heights. Just think! Gertrude! Medea!

ANNA: Ag, thanks. But I can't leave here. There's far too much for me to take care of. Not just the shops, but the properties too. Who'd collect my rents?

DU PRE: That is a great pity. But there is at least tonight.

ANNA: Yes. I'd like to act with you tonight.

ANTOINE: You'll be magnificent! Our show will be a great success. I thank you, gracious Anna.

ANNA: But there is one condition.

DU PRE: And what is that?

ANNA: (*Turning quickly around. Her cloak sweeps around her.*) When you come to dinner this evening (*She points to ABEL.*) I want him to stay behind. Just for tonight. This one night.

ABEL: I said there was something wrong!

DU PRE: What exactly do you mean?

ANNA: I want him to sleep with me in our marriage bed. He is my husband! That is where he belongs! I've been waiting so long. For three years and one month.
(*DU PRE, ANTOINE and SALOME stand there, amazed and apprehensive.*)

ABEL: Do you see now? I knew it!

DU PRE: Well, she is your wife. That's quite true.

ANTOINE: It's only for one night, love. It's not the end of the world.

ABEL: How can you even think… What are you saying?…

ANNA: We've had such lovely times in that bed. But surely you haven't forgotten? It's not been that long.

ANTOINE: And don't worry. There won't be any creepy-crawlies. The legs of the bed are in paraffin tins.

ANNA: That's right. (*To ABEL.*) And tomorrow morning
 you can leave again. I'll give you cold chicken to eat on
 the train. And egg sandwiches. Enough for all of you.

DU PRE: You're most kind.

ABEL: I'll never go into that house again. Never!

ANNA: But I did everything I could to make you
 comfortable.

ABEL: I hated it. Being smothered by your heavy body.
 The sour sweat in all the folds. You disgust me!
 (*Shocked silence.*)

DU PRE: Dear Anna, is there not something else we could
 do for you? Anything at all?

ANNA: (*To ABEL.*) So…is this how you repay me?

DU PRE: After all you will have the privilege of performing
 with our renowned company.

ANNA: You'll be sorry. All of you.

DU PRE: And it would be such a shame, dear Anna, to hide
 your great talent.

ABEL: (*To ANNA.*) You see? It didn't work!

ANNA: (*Taking the cape off.*) I'll be off then.

DU PRE: Please!

ANNA: Goodbye. (*She moves towards the door, but stops. She
 moves slowly back towards the bench where LENIE lay, and
 bends down.*) What's this? (*She touches the blood with
 a finger. She looks at her fingertip.*) Blood!

SALOME: No! You're wrong!

ANNA: Good Lord! But of course! I should have known!
 How could she have left so quickly? All the trains
 have gone!

ANTOINE: Somebody came to fetch her.

DU PRE: Yes. Her mother is on her death bed.

SALOME: Diphtheria!

ANNA: She looked so pale this morning. So transparent
 and fragile. That's what happened. (*She looks at ABEL.*)
 Believe me, I am very sorry.

SALOME: We can only hope and pray that she gets there
 on time.

ABEL: I don't know what you're talking about!

DU PRE: (*To ANNA.*) My dear Anna.

ANNA: Please don't presume to call me by my Christian name. She couldn't have vanished into thin air. I mean, that's impossible. Where could you have hidden her? (*She sees the skip.*) But of course! (*She moves quickly to the basket, opening it. She bends down as though she were going to touch LENIE.*)

ABEL: (*Quickly to her, grabbing her arm and pulling her back.*) Stay away from her! Stay away!
(*ANNA falls to the ground, but stands up again quickly, dusting herself off. There is a shocked silence. She moves to the table where her hat is lying. ABEL stands next to the skip and looks down at LENIE.*)

ANNA: (*Putting on her hat.*) I really don't know whether I could keep quiet about something like this. I don't wish to be compromised. It's quite possible that you will all go to prison.

DU PRE: We are blameless!

ANTOINE: It just happened.

SALOME: It was nothing to do with us!

ANNA: Oh, I know that. But who else will believe you? I mean, why hide the body? Why all the secrecy? I would advise you to pack and leave as soon as possible I don't see any alternative. Well. Goodbye. (*Moves to the door.*)

DU PRE: Wait! Wait…madam!

ANNA: (*Turning around.*) Yes?

DU PRE: Would you give us a moment to reconsider your conditions?

ABEL: Meneer, what are you doing?

DU PRE: It's only one night, for God's sake. It can't kill you.

ANNA: I must tell you that my conditions have changed.

DU PRE: Oh?

ANNA: You must discharge him. You must send him home to me. He is my husband. This is where he belongs. At my side.

SALOME: But how can we just…

ANNA: (*Imperious.*) Tomorrow when you leave, he must stay behind!

ABEL: No! Please! I'm an actor! Don't send me back! Every
 day's exactly the same! Year after year, day after day!
 Acid drops. Hessian. And chicken feed! And her always
 waiting for me in her big, white house!

DU PRE: Please! We have to make a decision! I think that it
 would be better if you waited outside.

ANNA: A little fresh air will do you the world of good.

ABEL: (*To DU PRE.*) I beg you, sir. Please.

DU PRE: I told you to wait outside!
 (*ABEL exits, slamming the door behind him.*)
 (*To ANNA.*) Would you be so kind as to sit over there for
 a moment? We need to discuss the matter privately.
 (*ANNA sits on a bench at the back of the stage, watching
 them.*)

DU PRE: That damned woman!

SALOME: And we were so nice to her!
 (*The following dialogue is rapid and quiet.*)

ANTOINE: We can't give Abel back to her. You said
 yourself that we must stand together or we're finished!

DU PRE: I know, I know. (*Softly.*) But if she says anything
 it's all over for us. Then we've lost our only chance. And
 who knows, we might easily end up in prison.

SALOME: (*Tearfully.*) What are we going to do?

DU PRE: I'm sorry to have to say it, but it's him or us. And
 I'm not just talking about the three of us. I mean the
 company. Our future. Our art!

ANTOINE: You really think that there's nothing else we
 can do?

DU PRE: No. I'm sorry. There doesn't seem to be another
 way out.

SALOME: Maybe he can join up with us again later on.

DU PRE: No! My word is my word!

SALOME: Poor Abel.

DU PRE: (*To ANTOINE.*) Tell him he can come back in.
 (*ANTOINE goes to the door and opens it.*)
 (*To ANNA.*) We accept. Will you perform tonight, madam?

ANNA: It would give me great pleasure. The greatest
 pleasure.

ABEL: (*Appearing in the doorway. All turn and look at him. Silence.*) You don't have to say anything. What else can you do? I warned you, didn't I?

SALOME: We'll never forget you. When we come here again, you can have as many comps as you like. And sit in the best seats.

(*ABEL sits on a bench to one side. Silence.*)

ANNA: (*To DU PRE, SALOME and ANTOINE.*) Stop looking at me like that! I know exactly what you think of me. But you don't understand. I'm nothing without him! He is my life! I want him! These three years have been a living hell! When he's not with me, the longing for him consumes me day and night. Burns me like the flames of hell. (*Silence. Suddenly brisk and business-like. Pointing at the basket.*) You must make some decisions. What are you going to do with the body?

DU PRE: We are going to transport her to another town by train, and bury her there.

ANNA: And you intend transporting a body like that? In a basket?

ANTOINE: What's wrong with that?

ANNA: It's not right, and what will happen if anyone were to find out? Fortunately, I can help make a more suitable arrangement. I have my coffin in the attic. I believe in being prepared. At the moment it is full of dried peaches, but the servants can clean it up. I had it made of a lovely dark wood. It has nice shiny handles and is lined with imported silk. After the performance, we must call the doctor and get him to write the death certificate. It'll all be fine. He's a personal friend of mine. And after that we can put her into the coffin. Leave it up to me. I know what to do.

ABEL: You will not touch her!

ANNA: Very well! Very well! And before you come to me for dinner, you can take her to the station.

ABEL: She's staying here tonight. With me.

ANNA: I suppose you should have a final farewell. After all, you'll never see her again. Dust to dust.

ABEL: I'm going with her. Tomorrow, on the train.

ANNA: That's quite proper. I'll also go to attend her funeral. (*She laugh. She stands behind ABEL with her hands on his shoulders.*) I'm never letting you out of my sight again. And when everything's been taken care of, we'll come home. And everything will be just as it was before. Understood?

ABEL: (*Softly, looking at his hands.*) Yes.

ANNA: (*Bending and kissing him on his head.*) That's my Abel.

DU PRE: Then everything's solved. (*He claps his hands.*) There's no time to be lost. We must rehearse! In costume! I want to see complete involvement!

SALOME: What do I wear first?

DU PRE: Can't you remember anything? The Angel in the opening tableau! The Angel! (*To ANNA.*) To begin with, madam, you wear the black robe and the mask. When you play Good Deeds, you must change. But don't worry about that for the moment.

(*During the following speeches, SALOME, ANTOINE and ANNA change. SALOME puts on a white nightdress, with great white wings and a golden crown. ANTOINE puts on a green, medieval jerkin, boots, a hat with a bedraggled feather and carries a bundle on a stick over his shoulder. ANNA puts on the robe and mask.*)

(*To ABEL.*) What are you sitting about for? You must change!

ABEL: Why should I, Meneer?

DU PRE: (*Quietly, resignedly.*) I expected this.

ABEL: You've betrayed me!

DU PRE: But you know why!

ABEL: Yes. I understand. But it's me that has to pay the price. (*Short silence.*) How can I act? I feel as if my life... is over. And I have to act with her! Wearing Lenie's costumes!

DU PRE: (*Moving to ABEL, sinking down on one knee beside him.*) You must go on! You must!

ABEL: Why should I, Meneer? With all respect. Why should I?

DU PRE: Not just for us! But for Everyman! (*Passionately.*)
He has survived for centuries and centuries. In hundreds
of languages and in hundreds of countries. And tonight
he could be *here*! And *these* people will see him! Not
Abel! Abel, the mortal. Abel, the weakling. But
Everyman! And then… (*He looks at him, lifts his arms up,
majestic.*) …something extraordinary could happen.

ABEL: (*Lifts up his head and looks at DU PRE. Silence. Softly.*)
Alright, Meneer. I'll go on, Meneer. (*He stands up, moves
away and begins dressing.*)
(*DU PRE is deeply affected. He remains kneeling, his
head bent.*)

SALOME: (*Concerned.*) What's wrong? Are you alright?
(*DU PRE turns his head slowly.*)
Then what's the matter? Tell me.
(*DU PRE turns his head and looks at SALOME.*)
Noekie! You're crying.

DU PRE: (*Standing up, stroking a finger over SALOME's cheek.*)
It's alright. All gone now. (*He moves away and begins
changing.*)
(*ANTOINE helps him, putting on the long, red cloak and
God's great, golden crown. ABEL wears a jerkin, and buckles
a sword to his belt. The costumes are well-worn and very
wrinkled.*)

DU PRE: (*Clapping his hands.*) We will begin at the top and
work through slowly in sequence. Antoine, bring a table
over here. It's for the Angel. (*To ANNA.*) As the curtain
opens, God is seated on his throne with his sceptre.
Behind him, with outstretched wings, stands the Angel.
(*Pointing at SALOME.*) No, here. Right at the back. Come
on, Angel, up on the table. (*He takes his sceptre and goes
and sits behind the altar.*) Is everybody ready?

ANNA: Yes.

ANTOINE: Yes.

SALOME: Just a second. The table's wobbling. There.

DU PRE: And Everyman? Are you ready?
(*Short silence. ABEL steps forward in his costume.*)

ABEL: (*Quiet and steady.*) Yes. I am ready. (*He turns his head
and looks at ANNA. Silence.*)

DU PRE: (*Moved. Dropping his head, and then slowly raising it again.*) Then, let's begin. (*He lifts his sceptre, speaking slowly and censoriously.*) 'I see here in my majesty how all mankind reviles me! He sees not my signs and is blind!' (*Suddenly, in his normal voice, to ANNA.*) Madam! I almost forgot! Do you have a decent photograph of yourself?

ANNA: To tell the truth, I had a rather nice portrait taken a few years ago.

DU PRE: Marvellous! Would you be so kind as to take it to the bookshop? It must be displayed at once. In the window. With an announcement stating that you will be appearing with us tonight. The sooner people are aware of that the better!

SALOME: But that won't be necessary, Noekie. Mine's already there.

DU PRE: The lady is our star tonight!

SALOME: How can you say that?

ANNA: (*Soothingly.*) Ag, it's just for one night. (*SALOME sniffs.*)

DU PRE: Behave yourself! You are a professional actress! You must set an example! (*To ANNA.*) You must hurry. Advertising is vitally important. Just think, tonight the entire community will stand dumbstruck before your phenomenal talent! (*ANNA laughs modestly.*) And could you tell everyone you meet along the way?

ANNA: (*Taking off her cloak and mask.*) Alright.

DU PRE: In the meanwhile, we will rehearse without you. Please don't forget the photograph.

ANNA: No, I won't. (*She puts on her hat, and is obviously excited.*)

DU PRE: Well, then let us begin again. (*He lifts his sceptre, and assumes his stage persona.*) 'I see here in my Majesty how all mankind reviles me. He lives without fear in this world, sees not my signs and is blind.'

ANNA: (*Exiting and closing the door firmly after her. Off.*) Heel, Wolf! Heel!

DU PRE: (*Short silence. He looks at the door. Louder.*) 'Lives without fear in this world, sees not my signs and is blind.'

(*He stops suddenly and moves to the door. He opens it slightly and peers out.*) Yes, yes...there she goes, round the corner. (*He turns around.*) She's gone! At last we've got rid of her!

ANTOINE: I don't understand.

SALOME: (*Still on the table with her wings spread out.*) What's going on? A moment ago she was your star!

DU PRE: Friends. (*Silence. Moved.*) Something extraordinary has happened here!

SALOME: (*Climbing off the table.*) What do you mean?

DU PRE: (*Lifting his arm and pointing at ABEL.*) Look at him. He has been through deep waters. His beloved has died. He has lost a child. We have betrayed him, abandoned him and sold him back into the power of a cruel, clever woman. He is broken. But still he puts on Everyman's jerkin, buckles on Everyman's sword and says, 'Yes. I'm ready'. Abel was a man. And an actor. But in that moment he became an artist. An artist! (*He goes to ABEL and stands in front of him. Softly.*) Bravo. (*He embraces ABEL.*) Forgive me. I almost made the most terrible mistake.

SALOME: You mean he can stay? You aren't going to send him away?

DU PRE: Not for all the world!

ANTOINE: She'll be very angry. You know what'll happen.

DU PRE: I'm not afraid of her. (*Excited.*) Don't you know what this means? I've been waiting for such a long time. I'm tired and I'm getting old.

ABEL: (*In amazement.*) And I'm not afraid of her either! I'm not afraid of her any more!

SALOME: You're not getting old.

DU PRE: I am. But I have just had to keep going. On and on without stopping. Forever. Otherwise everything would have foundered. (*He looks at ABEL.*) But not any more. Now I know... This company will continue! I name Abel as my successor!

SALOME: But there's still so much time left! (*She goes to DU PRE and puts her arms around him.*) You're still young. And strong!

DU PRE: (*Comforting.*) Yes, yes. (*He kisses her on the forehead.*) So much time left. Abel, please say that you accept.

ABEL: (*Moved.*) Yes, I accept, Meneer. I accept!

ANTOINE: But what are we going to do about…(*Nods in the direction of the door.*) …her?

DU PRE: We'll have to act fast. Gather together all the bits and pieces that you can carry. When she comes back, we must be far away.

SALOME: You mean, just leave everything else here?

DU PRE: Yes! What does it matter?

ANTOINE: But we don't have any money for a train.

DU PRE: Never mind the train! We're going on foot.

SALOME: All the way?

DU PRE: As far away as possible. And I make a solemn promise to you all. We will never see this hell-hole again!

ANTOINE/SALOME: Never again!

DU PRE: After we leave this place, we will make a new start. I can feel it!

SALOME: And then we'll travel first-class.

DU PRE: Yes! All the way to Kroonstad!

SALOME: And I'll wear my blue hat on the train!

DU PRE: No deconsecrated churches for us then. No school halls. Only the City Hall will be good enough for us.

ANTOINE/SALOME: (*Applauding.*) Bravo!

DU PRE: And we'll always stay in the best hotels!

SALOME: Lovely.

ABEL: Meneer…what about Lenie? I can't leave her here.

DU PRE: Of course not. You must carry her. We'll walk quite slowly and rest as often as we need to.

ANTOINE: So…when she gets back we'll be gone. My God, I wish I could see her face when she finds out.

SALOME: And the reception…the mayor with his gold chain and all the people!
(*ABEL opens the lid of the skip and looks at LENIE. There is deep sorrow on his face.*)

ANTOINE: She'll never live it down.
(*ANTOINE and SALOME laugh. They stop laughing abruptly when they become aware of ABEL and the open skip.*)

SALOME: (*Kindly. Approaching ABEL.*) And just think how happy Lenie will be to leave here.
(*She peers reluctantly into the skip. She gives a little cry.*)
I heard something. I think she sighed.

ABEL: (*Hopefully.*) Lenie! Lenie!
(*DU PRE approaches the skip.*)

DU PRE: (*Bending over LENIE.*) No... I'm afraid she's dead. (*To SALOME.*) You're too used to the theatre, my darling. (*Pointing at skip.*) If this had been Juliet she would have been in a deep swoon, a sweet sleep that only looked like death. (*Still looking at LENIE.*) And then...suddenly...she would sigh and open her lovely eyes. You see...anything is possible in an Art. It is a higher form of life!
(*Short silence as they all solemnly consider this.*)

DU PRE: (*Clapping his hands.*) Come now! We have to hurry! There's not much time left!

ANTOINE: We won't get very far before she finds out. What if she sends the law after us? It would kill me to go to jail. I can't bear anything like that. I'm really...much too refined.

SALOME: And I won't survive a single day!

DU PRE: Calm down, please. There's no need to worry. Why do you think I sent Anna to put her picture in the window?

SALOME: (*Petulant.*) Because she is the star.

DU PRE: Quite wrong. And why did I ask her to tell as many people as possible that she was performing with us tonight?

ANTOINE: Wait! Of course! If she sends the law after us now...how will she explain...

DU PRE: (*Triumphant.*) That she'd been willing to perform with criminals and murderers!

SALOME: Yes! What would the people say?

DU PRE: It would ruin her reputation as an upstanding citizen.

ANTOINE: I know these small-town people. Spreading rumours. Listening in on the party-line. Condemning everyone as sinners. They would make her life a living hell!

SALOME: Noekie, you're so clever! (*She kisses him.*)

DU PRE: (*Embarrassed.*) So, come on then. Get ready.

SALOME: And what about the costumes and the props?

DU PRE: Keep your costumes on and we take only what we need for *Everyman.* I said we'll perform *Everyman* tonight and nothing will stop us! I don't care if we perform it for sheep in the veld.

ANTOINE: Yes! Or for cows in a shed!

DU PRE: Come on. Hurry up! Abel, you're carrying Lenie, so you don't have to take anything else.

SALOME: But who will play Death and Good Deeds?
(*ABEL lifts LENIE out of the skip.*)

DU PRE: Well...Antoine can play Death.

ANTOINE: But you've always said that I'm too ordinary to play Death.

DU PRE: Ordinary is not a word I use. It would have been 'pedestrian'. 'Too pedestrian'. But that was long ago. Since then you have really come to light.

ANTOINE: (*Proudly.*) Well...I did feel I was improving. Thank you for giving me this opportunity.

DU PRE: You deserve it my dear Antoine. (*To SALOME.*) And you can play Good Deeds.

SALOME: But you've always said that I'm not young enough to play Good Deeds.

DU PRE: Nonsense. A misunderstanding. Great beauty like yours is ageless.

SALOME: (*Moved.*) Thank you.

DU PRE: (*Putting his arm around her tenderly.*) And can Everyman have a more faithful companion?
(*SALOME smiles up at him radiantly.*)

SALOME: But I don't know the words. And you know I'll never, ever read my lines in a performance.

DU PRE: Well... Abel can teach you along the way. He knows it very well. He's acted it so often.

SALOME: (*Sadly.*) With Lenie. I watched the two of you every night. It was so beautiful, it brought tears to my eyes.

ABEL: Thank you.

ANTOINE: And I will play my flute as we walk along. Then we won't feel so tired.

DU PRE: Excellent idea!

SALOME: (*To ABEL.*) Will you help me to learn the words? (*She opens her suitcase.*)

ABEL: Yes. I will.

SALOME: (*Putting the costumes into her suitcase.*) Do you know Lenie's words? Are you sure?

ABEL: Yes. I'm sure. (*He presses LENIE's head against his chest.*) 'Nay, Everyman. I will bide with thee. I will not forsake thee. All earthly things is but empty vanity'.

DU PRE: Are you ready, Antoine?

ANTOINE: Yes, I am.

DU PRE: Salomé?

SALOME: (*Putting her hat on.*) Yes, I'm ready. (*She picks up her suitcase.*)
(*DU PRE opens the church door wide. A blinding shaft of golden light falls across the stage.*)

ABEL: (*As if to LENIE.*) 'Fear not. I will stay with thee. Short our end, and soften our pain; let us go from here and never come again'.

DU PRE: I will walk ahead. Antoine will follow me, playing his flute. Then Salomé followed by Abel carrying Lenie. Understood?

ALL: Yes.
(*The line forms quickly. DU PRE in front is still dressed as God, ANTOINE behind him still dressed as Knowledge, then SALOME still dressed as Angel with tattered gauze wings, followed by ABEL dressed as Everyman. He is wearing his broken sword and is carrying LENIE.*)

DU PRE: Follow me!
(*As they walk into the blinding light, the triumphant sound of medieval wind-music up loud. The music keeps playing as the lights fade slowly on an empty stage.*)

The End.

Glossary of Afrikaans terms

Platteland: The country as opposed to the larger towns

Voetsek: Literally 'Go away!', usually used as an instruction to an animal or to a person in a derogatory sense. However, in this context ('nineteen-voetsek') it is slang simply indicating an unspecified, distant period

Tiekie: Sixpence

Mielie: Corn.

Meneer: Sir

Koeksuster: A syrupy confectionary made from dough

Sjoe: An exclamation similar to 'phew'